Photoshop Lightroom:
From
Snapshots to
Great Shots

Jeff Revell

Peachpit
Press

Photoshop Lightroom: From Snapshots to Great Shots
Jeff Revell

Peachpit Press
1249 Eighth Street
Berkeley, CA 94710
510/524-2178
510/524-2221 (fax)

Find us on the Web at www.peachpit.com
To report errors, please send a note to errata@peachpit.com
Peachpit Press is a division of Pearson Education.

Associate Editor: Valerie Witte
Production Editor: Becky Winter
Developmental Editor: Anne Marie Walker
Copyeditor: Anne Marie Walker
Proofreader: Erfert Fenton
Composition: Danielle Foster
Indexer: Valerie Perry
Cover Image: Jeff Revell
Cover Design: Aren Straiger
Back Cover Author Photo: Scott Kelby

ISBN-13: 978-0-321-81962-8
ISBN–10: 0-321-81962-4

9 8 7 6 5 4 3 2 1

Printed and bound in the United States of America

DEDICATION

For all my Snow Clan brothers, "Cover me, I'm reloading!"

ACKNOWLEDGMENTS

I worked with a new team on this book, and I have to say that they did a great job of keeping me on track while letting me do things in my own wacky way. I'm not always the easiest person to work with, so I want to thank them for their patience and understanding. Many people are involved in writing a book, but I especially want to thank Valerie Witte, Anne Marie Walker, Becky Winter, and my buddy Ted Waitt. I know there are many others, and even though I may not know you personally, I truly appreciate your efforts.

I also want to thank all of my Clan buddies for helping to keep me sane during this book writing process. If you are wondering what I'm talking about, I have a group of friends that play a certain online game on Xbox. We don't necessarily all play at the same time, but when we do get together, it's always a blast and a great relief from real-world stress. A special thanks to my buds Scott, Hans, RC, Matt, Pete, Jordan, and my sons, Alex and Matt (Chewy).

Of course, it wouldn't be right if I didn't thank my wonderful family for all their support, not only while I'm writing a book, but in every facet of my life. You make each day worth getting out of bed, and I am truly blessed to call you wife, son, daughter, mother, father, brother, sister, niece, and nephew. Your love and support do not go unnoticed.

Contents

Introduction

I've written quite a few books in the *From Snapshots to Great Shots* series, and most of them have been about cameras. My philosophy for writing them has been to provide readers with a good foundation for taking great photographs through the application of camera technology and knowledge. It's so important to understand the fundamentals and how to apply them when taking photographs. But is that all there is to making a good image? Well, it used to be.

There was a time when all you could control was the exposure of your film, and everything else was handed off to a photofinisher. It was the photofinisher's job to make sure that the film was processed correctly and that everything from that point on was done to produce a decent-looking image. Just how decent depended on who was doing the processing.

Today, you can still drop off your files at the local drugstore and get photos back, but if you want to get great-looking images, you need to take control of that other side of the photography coin—the image processing. That's why I wrote this book, because showing you how to take a great photo is just part of the equation. To get the most from your photographic efforts, you need to learn how to finish the photo by using software tools like Adobe Photoshop Lightroom.

The old saying—*Give a man a fish, feed him today. Teach a man to fish and you feed him for life*—is really not that simple. You have to teach him not only how to catch it, but also how to clean it and cook it. Otherwise, he just has a bunch of fish that he doesn't know what to do with. This book will take you beyond the catching phase. Once you have caught your fish, you'll learn how to clean it and cook it, and make it a truly great meal.

I hope I've given you some clues as to what this book is about, but if you still aren't sure, read the following Q&A.

Q: WHY ADOBE PHOTOSHOP LIGHTROOM?

A: It's true that there are a lot of image processing programs on the market to choose from, but I wanted to use a program that had all the power to handle many different image file types, including raw and JPEG. The program also needed enhancement tools that were fairly simple to use but were also very powerful. I also wanted to ensure that there would be image management as well as lots of output options. Photoshop Lightroom has all of these features and more. It has a great image management feature called the Library, and many of the same great tools as its cousin, Adobe Photoshop. Lightroom uses the Adobe Camera Raw engine for complete control over image processing plus some great productivity tools for making books, slide shows, and more.

Q: DOES IT MATTER IF I HAVE A MAC OR WINDOWS MACHINE?

A: No. The program performs almost identically on either platform. When there is a difference between the keyboard shortcuts, I list the Mac shortcut first, followed by the Windows shortcut in parentheses, like this: To deselect, press Shift+Command+A (Shift+Ctrl+A in Windows). The screen captures in this book were made on my Mac, using the OS X Lion operating system, so you might see some aesthetic differences (buttons, cursors, and the like), but overall the program interface should look almost identical.

Q: YOU WROTE THIS BOOK USING LIGHTROOM 4; DOES THAT MEAN I CAN'T USE IT WITH MY EARLIER VERSION?

A: Not at all. Notice that there is no version number on the front of this book. The reason is that most of the tasks you'll be doing will be general in nature and use the same tools that have been available in previous versions of Lightroom. I've tried to focus on the basics of image processing, so I address color correction, cropping, exposure adjustments, sharpening, and so on. The tools to perform these operations have changed little over the years and will still be available in future versions as well. They are the core elements of image processing, and just like f-stops and shutter speeds, they will probably change very little in the future. I do my best to point out where there are differences as well as when some features are not in earlier versions so you can just skip ahead.

Q: DO YOU COVER EVERY FEATURE?

A: Not even close. Lightroom is jam-packed with so many features that this book would be many hundreds of pages long if I covered them all. My focus for this book is to bring you the information and techniques necessary to take images from your camera and enhance them into great shots. I also want you to be able to hit the ground running without getting bogged down by the nitty gritty. As in my camera

books, I'll cover the tools and features that will give you a great image processing foundation and let you start improving your photos right away.

Q: WHAT CAN I EXPECT TO LEARN FROM THIS BOOK?

A: I like to think of image processing as a three-step process. The first step is importing, where I move images from my camera to my computer. The second step is when I work on my images, giving them the right treatment to really fulfill the vision I had when I took the photo. The third step is to output my images in some way, whether it's making prints to hang on the wall or sharing them online with friends, family, or even clients. These are the processes that you will learn. They aren't overly complicated or advanced, but you don't have to tell anyone that.

Q: WHAT ARE THE ASSIGNMENTS ALL ABOUT?

A: At the end of each chapter, you'll find short assignments where I offer suggestions as to how you can apply the lessons of the chapter to help reinforce everything you just learned. A lot of the information covered in the chapters will be new to you, and I'm a firm believer in learning by doing. The assignments are simple exercises that will help you gain a better understanding, and also allow for a nice break, before moving on to the next chapter.

Q: IS THERE ANYTHING ELSE I SHOULD KNOW BEFORE GETTING STARTED?

A: In order to keep the book short and focused, I had to be pretty selective about what I put in each chapter. The problem is that there is a whole other chapter that I wanted to include, but I just couldn't make it work. But instead of just leaving it out and shortchanging you, I have included it as a bonus chapter. So what's in this bonus chapter? It's a step-by-step accounting of my Lightroom workflow from import to exporting and printing. To access the bonus chapter, just log in or join peachpit.com (it's free), and then enter the book's ISBN. After you register the book, a link to the bonus chapter will be listed on your Account page under Registered Products.

Q: IS THAT IT?

A: I know what fun it can be to share what you've learned with others and maybe even show off a bit. To that end, I invite you to show off your before-and-after shots in the *Lightroom: From Snapshots to Great Shots* Flickr group. You've worked hard learning new skills, so go ahead, join the group, and show everyone your great shots. Just point your browser to www.flickr.com/groups/photoshoplightroomfromsnapshotstogreatshots, and join in on the fun. I'm looking forward to seeing your work.

1

ISO 400
1/500 sec.
f/6.3
12mm lens

From Camera to Computer

IMPORTING YOUR IMAGES

This may seem like a pretty elementary place to start, but let's face it; you can't do anything to your photographs until you get them into your computer. Believe it or not, this is where the workflow can really go wrong for a lot of people. What do I mean? Well, being organized is the main component for a fast and efficient workflow. By developing a plan for how and where to store your photos, you will be well on your way to working faster and being able to find your photographs later when you need them. The first step in this process is importing your images.

I can't tell you how many times I've looked through someone else's computer hard drive and found images scattered about in numerous folders with no rhyme or reason to the organizational structure. If you are lucky, all your images might be located in the My Pictures folder, but that's not always the case. The best way to combat this chaos is to organize your images from the moment that you import them to your computer. So let's check out the Lightroom Import function and start importing some photos.

Each module has panels on each side that allow you to quickly access program functions.

Easily import pictures into Lightroom directly from your camera or a card reader.

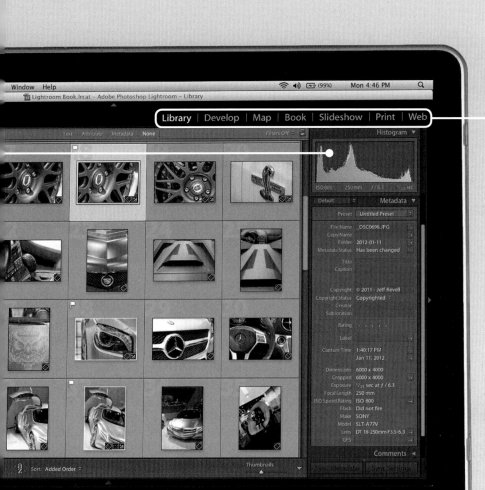

Quickly move between the different modules by clicking the module titles.

IMPORTING PHOTOS FROM YOUR CAMERA OR CARD READER

I love taking photographs. Working with my camera and accessories to capture a moment is one of my most fulfilling experiences. But what have I really done up to that point? I have captured the image on a memory card and probably looked at it on the camera's LCD screen. There's not a lot else you can do with an image while it sits in your camera, so importing it into your computer is the next logical step.

Adobe Photoshop Lightroom allows you to perform this process either by connecting your camera to the computer or by removing the card from the camera and using a connected card reader. Let's start importing pictures from your camera. To do this, you'll need a USB cable, which most likely was included with your camera when you bought it.

Before attaching your camera to the computer, read your camera's manual for any specific instructions related to this procedure.

When you have the camera attached and turned on, open Lightroom and then click the Import button located at the bottom of the left panel in the Library module (**Figure 1.1**) (the keyboard shortcut for performing this action is Shift+Command+I for Mac or Shift+Ctrl+I for Windows).

FIGURE 1.1
Click the Import button to open the Lightroom Import dialog.

If the Import dialog looks like **Figure 1.2**, click the Show More Options arrow located in the bottom-left corner of the box. This will open the full dialog, which also lets you preview all of the images that you are getting ready to import.

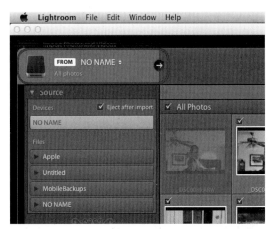

FIGURE 1.2
Click the down arrow to see all of the Import options.

After opening the Import dialog, you'll need to make some decisions before moving forward. You'll first need to make sure that your source is selected (**Figure 1.3**). Lightroom typically looks for any attached cameras or card readers and defaults to them for importing. The source location is at the top-left side of the dialog and is identified by the FROM label.

The next step is to determine how the images will be moved onto the computer. If you look in the center section of the Import title bar, you'll find options for saving your files (**Figure 1.4**). The default method is to copy your images from the camera or card. This creates an exact copy and leaves the originals intact in the camera. Another option is to Copy as DNG. DNG is Adobe's name for Digital Negative files and was created as an alternative to the various types of raw files. It is meant to provide the same functionality with the added bonus of being open source and ensuring archival dependability so that images can be opened years down the road.

FIGURE 1.3
The name of your camera or memory card should appear in the top-left section of the dialog.

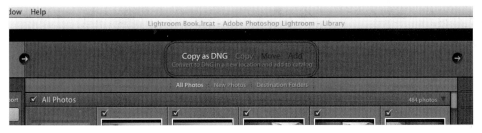

FIGURE 1.4
You can choose to copy or copy and convert to DNG in the top section of the dialog.

STAYING CONSISTENT

It's generally a good idea to stay consistent with your file hierarchy. Try to pick a default folder location for all your images, and then change the individual subfolders as necessary. Lightroom will default to whatever you selected last for the import folder, and having a consistent default folder will help speed up your import process.

Another benefit to saving your files as DNGs is that the format takes up less physical space on a hard drive than most raw formats. Of course, this is a moot point if you are shooting in the JPEG format (more on this later).

Once you have decided to either copy your files or convert them to DNG, you then need to decide how to organize your images. The right side of the title bar shows the destination location for your imported photos. The default location is the Pictures folder, but you can easily change this to another location by clicking the drive icon (**Figure 1.5**). Select Other Destination from the pop-up menu, and then select the desired folder in the Choose Destination Folder dialog (**Figure 1.6**). You can also choose to create a new folder instead of using an existing one.

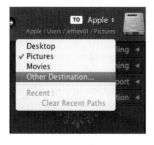

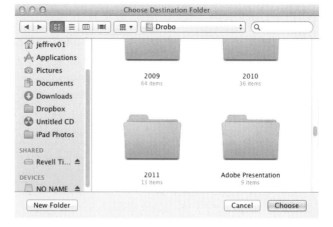

FIGURE 1.5
Click the top-right section of the Import dialog to set your download destination.

FIGURE 1.6
Navigate to the destination folder, click it to select it, and then click Choose.

FILE HANDLING

Now that the basic import information is all set, you need to address some options in the panel on the right. The first module is labeled File Handling, and it does a couple of important tasks for you. Render Preview lets you choose how the image previews are rendered. The preview is how the image looks in the Library viewer, and your choice here determines how much time the import takes as well as how long it takes to see the fully rendered 100 percent preview in the Library. If you select Minimal (**Figure 1.7**), Lightroom imports your images and generates a low-resolution thumbnail that appears in the Library. When you click the Loupe view (E key) to see an enlarged version, it will take a little while for Lightroom to render the view.

FIGURE 1.7
To select your preview quality preference, click the Render Preview drop-down menu.

The Embedded & Sidecar option imports the low-resolution JPEG thumbnail that your camera created and that is embedded in your image file, and uses it as the initial preview thumbnail in the Library until it can build higher-quality thumbnails. The embedded JPEG is the same image that you see on the back of your camera when you take a photo.

The Standard option imports a low-resolution thumbnail and also builds higher-resolution previews for when you double-click a thumbnail to enlarge it. It can take a while for Lightroom to build these previews, especially if you have some high-resolution images.

The 1:1 option takes the longest of all the previews because it builds a full, 100 percent resolution preview for each imported file. Although this option takes the longest, you won't have to wait to see an enlarged preview in Lightroom or even the 1:1 zoomed-in view.

TIP

Large image previews, such as those created in the 1:1 mode, can take up some serious space on your hard drive, which is why you can have Lightroom discard them after a period of time. The default is 30 days, but you can also choose One Day, One Week, or Never if you always want them available. To set this option, look for Catalog Settings in the Lightroom menu or Edit menu in Windows. The preview options are located in the File Handling section of the Catalog Settings dialog.

My personal preference for previews is to use the Minimal setting. This means that I can access my images in the Library much faster and can start sorting them right away. If I want to see a larger view of the image, it takes just a few seconds for it to render. Also, there is no sense wasting processing time rendering previews for images that might be discarded later.

Another option you need to address in the File Handling module is the Don't Import Suspected Duplicates check box. It's quite probable that you will shoot some photos, import them into Lightroom, and then shoot more pictures without deleting the previous images. By selecting this option, Lightroom will look at the images on the card and determine if they have already been imported. If so, they will be grayed out on your import screen and automatically not selected, which can be a huge time-saver.

FILE RENAMING

Normally, I leave my filenames as they are when importing, but you might prefer using a filename that has a little more meaning than DSC_1511.NEF. If so, click the File Renaming module and select the Rename Files check box (**Figure 1.8**). Then click the Template drop-down menu and select the type of file naming convention you want to use. You'll have several options to choose from. Depending on the selected option, there will be other fields in the box that you'll need to address to complete the process. For example, let's say you did a portrait shoot and want to import those images with a custom name.

1. Click the Template drop-down menu, and select Shoot Name – Sequence (**Figure 1.9**).

2. Click in the Shoot Name box and type the name of the shoot (**Figure 1.10**).

3. Select the Start Number for the sequence to make sure that it starts with the number that you want. All images will be added and labeled sequentially starting with this number.

4. Look at the filename example at the bottom of the module to ensure that it looks the way you want it to; then import your images.

Just remember to adjust the filename option every time you import new images.

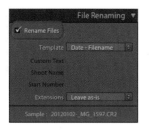

FIGURE 1.8
Select the Rename Files check box if you want to change the image filenames during import.

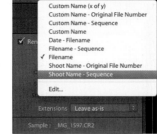

FIGURE 1.9
Select Shoot Name – Sequence if you want to name your files by photo shoot.

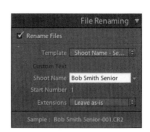

FIGURE 1.10
Enter a unique name in the Shoot Name box.

APPLY DURING IMPORT

During the import process, I like to do a few things that not only help keep me organized, but also let me add some personal data to my images, such as copyright and contact info. This is very helpful if I plan on selling or displaying my images online. It's also a quick way to add some image processing to all the imported photos using a Lightroom preset.

When you click the Apply During Import module, you'll see a Develop Settings drop-down menu (**Figure 1.11**). These are preset processing settings that will change the overall look of your image. They originate in the Develop module and will be covered in more detail in Chapter 3, but a quick scan through the choices will be self-explanatory. There are presets for creating black and whites and adjusting color effects, and general selections for adding some visual impact to your images.

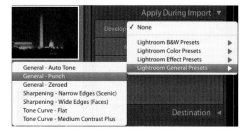

FIGURE 1.11
You can choose from several Develop presets during the import process.

Generally, I don't use any of the Lightroom presets because these settings will be applied to all of the imported images, which is probably not what I want. I like to apply the settings individually in the Develop module where I can see the results for each image. However, I do like to create my own Develop Settings that I always apply to my photos during import, such as basic sharpening and clarity boosting. I'll cover this process later in Chapter 3.

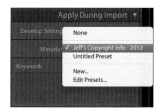

FIGURE 1.12
You can apply your own copyright info in the Apply During Import section.

CREATING A METADATA PRESET

The one thing that I consistently add to all of my imported images is copyright/contact information. This is done via the Metadata drop-down menu (**Figure 1.12**). But before you can add this type of info, you first need to create your metadata preset.

1. Click the Metadata drop-down menu and select New (**Figure 1.13**).

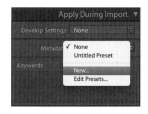

FIGURE 1.13
Select New in the Metadata drop-down menu to create your own unique copyright template.

FIGURE 1.14

Fill in the appropriate sections of the metadata preset and then click Create to finalize the preset.

FIGURE 1.14
Fill in the appropriate sections of the metadata preset and then click Create to finalize the preset.

2. When the Metadata dialog opens, fill in the Preset name; then scroll down to the IPTC Copyright section, and fill in all of the appropriate info (**Figure 1.14**).

3. In the next section, place a check mark next to IPTC Creator and then fill in all of the personal contact information that you want embedded in the image.

4. Deselect any of the options that you don't want to appear in the metadata.

5. Fill in any of the remaining sections as you see fit, and then click the Create button.

The new metadata preset will be selected by default and will then be added to all of your images during import.

TIP

Adding copyright and contact information is extremely important if you plan on doing anything commercially with your images, especially online. If someone finds the image and wants to license or buy a copy, that person can look at the metadata and find all of your contact information to reach you. It's also a good practice in terms of asserting your rights over the image. However, simply adding a copyright message is not enough to protect your images. For complete protection, your images should be registered with the National Copyright Office. In the United States, check out www.copyright.gov for more information.

The other significant piece of information that you can add in the Apply During Import section is keywords. Keywords are descriptive words or phrases that help you organize and search for your images later on. You can assign multiple keywords to your images if you want (**Figure 1.15**). Just remember that any keywords that you add during the import process will be added to all of the imported photos, so make sure they are applicable, especially if you are importing photos from several different shooting events at the same time. You can also add keywords after import from within the Library module.

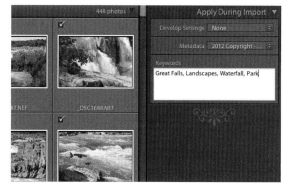

FIGURE 1.15
Type descriptive words in the Keyword section to apply them to the imported images.

DESTINATION

The last setting you need to configure before importing your images is the folder location for your images. The default setting organizes your images by date and places them into folders by year and then by the date the images were taken. Lightroom looks at the metadata that is embedded in the images by the camera for this information, so if you plan on using this option, you should make sure your camera is set to the proper date. There are several options for how the folders will be labled, for example, 2012-01-06 or January 06 (**Figure 1.16**). Just choose the option that is right for you.

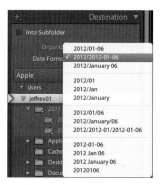

FIGURE 1.16
Lightroom uses the date as the default download folder name.

If you aren't keen on using dates and would like to use unique folder names, choose the Organize Into One Folder option (**Figure 1.17**). Then select the folder from the folder tree where you would like all of the images to be stored. You can also select the Into Subfolder option, which allows you to create a subfolder with the name of your choice inside the folder you select.

FIGURE 1.17
You can change the Destination option so that all of your images are imported into a single folder.

I like to use the date option because I associate my photos with the dates they are taken. It's just the way my mind works. But you should select the method that best suits your preferences.

SELECTING FILES FOR IMPORT

Up until now you have just selected the parameters for importing your images. Now it's time to look at the images you're getting ready to import. The center section of the Import dialog should be displaying thumbnails of all of the images that are ready for import. This thumbnail layout is called the *Grid view*. You can adjust the size of the thumbnails by moving the thumbnail slider at the bottom right of the image preview area. If you want a larger view of one of your images, click the thumbnail to select it and then press the E key to enter Loupe view. To go back to Grid view, just press the G key.

Notice that all of the thumbnails have a check mark located in the top-left corner of each image. This check mark is your way of designating which images you want Lightroom to import. If you have previously imported some of the images from your memory card, those thumbnails will be grayed out with no check mark option (**Figure 1.18**).

FIGURE 1.18
Lightroom will ignore previously imported photos by default.

If this is the case and you want to only view those images that have not yet been imported, click New Photos on the bar above the thumbnails (**Figure 1.19**). The Destination Folders option will divide the thumbnails into sections by date.

The nice thing about looking at your images prior to importing is that it gives you a chance to only import the images you want to keep. If you're like me, there will always be a few photos that aren't worth looking at because the exposure was really messed up or the camera misfired, or whatever. For those images you do not want to import, simply deselect the image and Lightroom will not import it (**Figure 1.20**).

FIGURE 1.19
You can change how Lightroom displays the photos to be imported by changing the options above the thumbnail previews.

FIGURE 1.20
To skip images during import, just remove the thumbnail check mark.

FIGURE 1.21
Lightroom displays the status of your import in the upper-left corner.

You may also have just a few images out of a large group that you want to import. Instead of deselecting several thumbnails, just click the Uncheck All button at the bottom of the Grid view, and then select the few images you do want to import.

When you have all your options set and selections made, click the Import button at the bottom right of the dialog. Lightroom will take you back to the Library view where you can watch all of your photos pop up in the image preview screen. The Import progress bar at the top left of your screen indicates the status of the import process (**Figure 1.21**).

CHANGING THE AUTO IMPORT SETTING

Lightroom is set up to automatically start the import process when it recognizes a camera or card attached to the computer. If you want to turn off this option, open the Lightroom Preferences (Lightroom › Preferences on the Mac and Edit › Preferences in Windows) and click the General tab. In the Import Options section, deselect the "Show import dialog when a memory card is detected" check box (**Figure 1.22**).

FIGURE 1.22
Head to the General tab in Preferences to turn off auto import for memory cards.

ADDING IMAGES ALREADY ON YOUR COMPUTER

Chances are that you already have images stored on your computer, but that doesn't mean that you can't use them in Lightroom. The fact is that Lightroom makes adding existing images easy, and you'll find it easier to get organized after you add them to your catalog. To add images, access the Library module in Lightroom by pressing Command+Alt+1 (Ctrl+Alt+1) and then click the Import button. When the Import dialog opens, click Add in the top bar (**Figure 1.23**). Then locate the files you want to add to Lightroom. In the left panel you'll find the Source drop-down menu. Use the menu to locate the folder where your photos are stored on your computer. Just navigate to the desired folder and Lightroom will show you thumbnails in the preview area of all your images (**Figure 1.24**). You can also select the Include Subfolders check box if you want to include images that might be in subfolders within the folder you selected. So, for example, if you want to add all the images in your Pictures folder, just click on that folder with the Include Subfolders check box selected and Lightroom will add all files and folders. If you only want to add specific images, deselect the Include Subfolders check box.

After you have identified the folder(s), go to the preview area and look at the thumbnails to make sure you are adding only the photos you want. By default, all images will have a check mark, so if you don't want an image added, just deselect it.

Finally, add any metadata or keywords that you want, and then click the Import button. The great thing about adding images is that Lightroom won't move them or create copies. All your images will stay where you originally stored them, but you'll be able to work on them easily from within the Lightroom catalog.

FIGURE 1.23
To add files already on your computer, change the import option to Add.

FIGURE 1.24
Locate the images to be added in the Source section of the Import dialog.

CREATING YOUR OWN IMPORT PRESET

After you have set all of the options in the Import dialog, you might want to create your own preset to save time the next time you import photos. It only takes a couple of seconds to do.

1. After setting all of your options, in the Import Preset section at the bottom of the Import dialog, select None to bring up the options (**Figure 1.25**).

FIGURE 1.25
Select the None option to open the pop-up menu to access the preset options.

2. Choose Save Current Settings as New Preset.

3. Type a name for the preset, and then click the Create button (**Figure 1.26**).

4. The next time you want to import photos, click the Import Preset drop-down menu and select your preset (**Figure 1.27**).

FIGURE 1.26
Name your preset.

FIGURE 1.27
Select the new preset to make it active for the current import session.

TETHERED CAPTURE

If you like to shoot in a studio or other controlled situation where you can connect your camera to your computer, you might want to check out the built-in Tethered Camera option. Tethered capture means that your camera is connected to your computer via a USB cable, and every photo you take is automatically imported into Lightroom. This setup isn't for everyone, and not every camera will work. But if you have a supported camera and a desire to see your images stream into Lightroom so that you can see them in large previews, this feature is for you.

USING TETHERED CAPTURE

To determine if your camera is supported in Tethered Capture, launch your web browser and search for "Lightroom Tethered Camera Support." You should easily find a link to an Adobe support article that will list all of the supported cameras. In a nutshell, tethered support is almost exclusive to Canon and Nikon DSLR cameras.

1. To start the tether operation, connect your camera to your computer via USB (a 10- to 15-foot USB cable is desirable for more shooting freedom).

2. Choose File > Tethered Capture > Start Tethered Capture (**Figure 1.28**).

3. Set your tethering options in the Tethered Capture Settings dialog and click OK (**Figure 1.29**).

4. When the Tether control bar opens, turn on your camera and press the shutter button to make sure it is on and awake (**Figure 1.30**). You should see your camera's name in the Tether control bar as well as the current camera settings.

5. Start taking photos. You can either use the camera's shutter release or click the gray circle on the Tether control bar to take photos.

As you start taking photos, the images will appear in your image preview area. To see the enlarged preview, press E to switch from the thumbnail (Grid) view to the enlarged Loupe view. Every time you press the shutter, the image will be added to your catalog and will appear as an enlarged preview.

FIGURE 1.28
Go to the File menu to start using Tethered Capture.

FIGURE 1.29
Set tethered options before beginning the session.

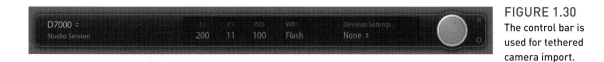

FIGURE 1.30
The control bar is used for tethered camera import.

FIGURE 1.31
The Auto Import Settings are accessed from the File menu.

FIGURE 1.32
Name the new watched folder.

FIGURE 1.33
The Auto Import Settings dialog.

AUTO IMPORTING FROM A FOLDER

Auto importing is one of those Lightroom features that many people don't really know about. But once you set it up, you'll use it all the time. So here's how it works: You set up a folder in your computer as a watched folder. Lightroom will then watch the folder for new content. When you add images to the folder, Lightroom will automatically import them to a more permanent location and add them to your catalog. I love using this option for when I take pictures using my mobile phone, because all I have to do is drag them into the folder and Lightroom does the rest.

SETTING UP AUTO IMPORT

You need to set a few options prior to using the Auto Import feature.

1. Choose File > Auto Import > Auto Import Settings (**Figure 1.31**).

2. When the Auto Import Settings dialog opens, click Choose in the Watched Folder section and then select or create a watched folder (remember that images won't remain in that folder, so it might be a good idea to create a new folder) (**Figure 1.32**).

3. Set the destination folder where you want Lightroom to move the images during import.

4. Finish setting up the rest of the Import options, and then select the Enable Auto Import check box at the top of the dialog. Click OK (**Figure 1.33**).

The Auto Import is now ready to roll. Simply add images to your watched folder and Lightroom will do the rest. If you want to turn off Auto Import, just choose File > Auto Import > Enable Auto Import to turn it off. To turn it back on, choose Enable Auto Import again.

Chapter 1 Assignments

You might have already imported images using the Import dialog, but here are a few tasks to practice just in case you haven't.

Make a Plan

Take a look at how your photos are currently stored on your computer. Are they scattered around in different folders based on what you were doing or thinking at the time? Well, it's time to get organized. Spend a few minutes thinking about how best to organize your images. Sketch out a tree diagram to help you plot your future imports.

Getting Started with What You Already Have

Because you have just looked at your computer files to find your photos, why not import them into Lightroom now so that you can start your organization efforts right away? Remember that you can import a single image as well as whole folders and subfolders. Start by importing just a few images before adding them all to Lightroom so that you can become familiar with the process.

Time to Move from Camera to Computer

Even if you don't have a card full of images waiting to import, I'm sure you can find something to point your camera at so you can practice importing those images into Lightroom. Or, if you are like some people I know, you probably have several months worth of images just waiting to be loaded onto your computer. Well, there's no time like the present. Hook up your camera or card reader and move your images to their new home.

Presets Make the Job Go Faster

While taking the time to set up options for import, why not take a few extra seconds and create an Import preset. You don't have to use it every time, and you can always delete it. But a well-thought-out preset will save you a lot of time in the future.

Share your results with the book's Flickr group!

Join the group here: flickr.com/groups/photoshoplightroomfromsnapshotstogreatshots

2

ISO 800
1/125 sec.
f/5.6
60mm lens

Keeping Track

FINDING AND SORTING YOUR IMAGES

In Chapter 1 I covered the import process to successfully download your images, but that is just the first step. Your photographs will be of no use if you can't find them when you need them. For this reason, it is important to be organized from the start. Fortunately, Lightroom has many good tools to help you keep your images neat and tidy.

In this chapter you'll learn about tagging and sorting images, and creating collections to help you organize your photos so that in the future you will have a much easier time finding the picture you want to use. You will also have a much easier method of eliminating the photos that you don't want.

Let's head on over to the Library and start sorting some images.

PORING OVER THE PICTURE

I came across this great location while driving in southern Nevada. Unfortunately, it was getting late in the afternoon, and the sun was quickly slipping behind the surrounding mountains, making the whole scene a bit dark. This shot required the use of a higher ISO, which meant there would be some noise in the image. Also, the exposure was based on the brightest part of the sky to keep it colorful, but that meant that the buildings and foreground would be underexposed. Fortunately, Lightroom has several tools to fix all of these problems.

Setting the color temperature to 6238 helped warm up the scene.

ISO 800
1/1000 sec.
f/5.6
55mm lens

Setting the Luminance
Noise Reduction to 48
eliminated the ISO noise.

Using some extra Clarity,
the rustic nature of the
wooden buildings was
emphasized.

Because the buildings
were extremely under-
exposed, I raised the
Shadows slider to 100.

TAGGING IMAGES WITH KEYWORDS

After you've imported your photographs, you'll have quite a few ways to find them within the Library. One of my favorite ways to keep track of my images is to assign keywords to them. Lots of people think that keywords are only used when you'll be shooting stock photography and need keywords for people to find your photos. This is true; but I use them for all of my photography as a way to quickly find images by subject matter.

Lightroom offers you several ways to assign keywords, and it's one of the easiest methods for quickly locating images by topic. Let's say, for example, you like to take photographs of flowers. If you mark all of your flower photos with the keyword *flower*, you'll then be able to see your entire collection of flower photos grouped together, even if they were shot and uploaded on different days. One of the great benefits of assigning keywords to your images is that you can apply multiple words so that your images will appear in a variety of categories. For example, if you use the keywords *flower* and *red* every time you take a picture of a red flower, you can then locate all the similarly tagged images with just a few mouse clicks.

In the Keywording panel in the Library is a section called Keyword Tags where you can add custom keywords for your images (**Figure 2.1**).

The easiest way to create a keyword tag is to click the image that you want to assign the keyword to, click inside the text box, and then type the keyword that you want to use for your image. One of the nice features of the text box is that it dynamically shows you existing keywords as you begin to type. So, for instance, if I've already used the keyword *Valley of Fire* and I have additional images I want to tag with this keyword, I just have to type the letter **V** into the text box and I'll see the words Valley of Fire appear below the text box. Then all I have to do is click it to fill in the rest (**Figure 2.2**).

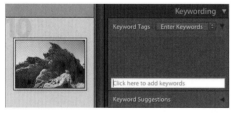

FIGURE 2.1
Add new keywords by typing them in the Keywording panel.

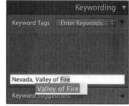

FIGURE 2.2
Existing keywords will pop up as you type.

If you want to assign multiple keywords, just add a comma after typing each word. Press Enter when you're done, and you'll see that the keywords you just typed are now in the box above the text entry field. It's important to remember that keywords will only be assigned to selected images. After the keywords are assigned, a tag appears on the bottom-right section of the image thumbnail(s) (**Figure 2.3**).

The great thing about keywording in Lightroom is that it remembers past keywords used and displays them in a suggestion list for you to quickly pick from. Of course, this list will grow as you increase the number of keywords you use, and as a result will not display every keyword ever used. Instead, Lightroom will suggest keywords that were used in recent imports (**Figure 2.4**).

Another nice feature in the Keywording panel is Keyword Sets, which allows you to create customized sets of keywords that you can use to tag specific types of photography. So, for example, if you shoot weddings, you can create a set that is specific to the types of photos you might take, such as Bride, Groom, Group, Reception, Ceremony, and so on. In fact, if you click the drop-down menu in the Keyword Set section, you'll find a preset for Wedding Photography (**Figure 2.5**). You can edit these sets by clicking the keyword set list and then choosing Edit Set. You can then choose the set you want to edit and the keywords for that set. You are limited to nine words per set, so choose carefully (**Figure 2.6**).

FIGURE 2.3
A small tag lets you know the image has a keyword assigned to it.

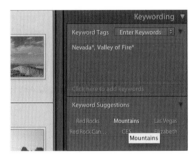

FIGURE 2.4
Recent keywords will be offered as suggestions.

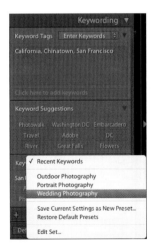

FIGURE 2.5
The Keyword Set selection menu.

FIGURE 2.6
The Keyword Set editing dialog.

It's not unusual to want to work with several images at once, so it's important to know how to select more than just one image. To select multiple images, click the first image, hold down the Command (Ctrl) key, and then click the additional photos you want included in the selection. If you want to select a contiguous group of photos, scroll to the top of the group and click the top-left thumbnail in that group. Then scroll down to the last image in the group and click it while holding down the Shift key. You can deselect any images in the group by Command-clicking (Ctrl-clicking) on them. If you want to select all of the images in the current collection, press Command+A (Ctrl+A). You can also access all of the selection options from the Edit menu.

ASSIGNING KEYWORDS TO MULTIPLE IMAGES

Assigning keywords is a pretty simple process. Just select the image thumbnails, type the keyword you want to assign in the Add Keyword panel, and press Enter. You can also drag and drop a keyword from the Keyword List onto any thumbnail to tag it.

Any of the following three methods will work with a group of images. Select the images that you want to add the keyword tag to and do one of the following:

- In the Keywording panel click in the text box to add your keyword.

- Click the keyword in the Keyword Suggestions section.

- Locate the keyword that you want to add in the Keyword List and drag it onto one of the selected images.

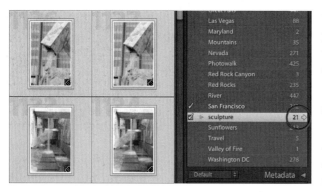

FIGURE 2.7
Click the arrow to display images with a particular keyword tag.

Choose the method that you prefer. After you've added the keyword tag, you'll see the total number of photos with that keyword in the Keyword List (**Figure 2.7**). To see just those keyworded images in the image preview area, click the right arrow next to the number of images that have that keyword assigned (the arrow appears when you hover your mouse over the keyword in the list). Lightroom will hide all other images that don't have that keyword tag. This is a great way to filter your images to quickly locate the images you want to see.

SORTING IMAGES

Using keywords is a great way to categorize your photos, but there are numerous ways to sort images within the Library to help you separate the wheat from the chaff. After importing images from a photo shoot, I first like to get rid of all of the images that just don't make the grade—for example, those photos that are poorly exposed, out of focus, or simply just bad shots. They have no place in my Library or on my hard drive.

FLAGGING PHOTOS

One of the fastest methods for sorting photos is to use flags. You can quickly tag your photos with two differ-ent flags by using keyboard shortcuts as you view your imported images. You add the Picks flag to an image by pressing the P key. I usually use this flag for my best shots. You can also add this flag to a group of images by selecting them and pressing the P key.

For images that you want to throw away, you can use the Rejects flag. To add a Rejects flag to an image, just select it and press the X key. As with the Picks flag, you can also reject groups of images by selecting them and pressing the X key.

As you start sorting with flags, a white flag appears in the top-left corner of the thumbnails for your Picks and a black flag with a small X in it for the Rejects. Also, the rejected images will be grayed out (**Figure 2.8**). This is just another visual tool to help you easily see which images have been rejected.

FIGURE 2.8
Rejected photos are grayed out and display a black flag with an X in it.

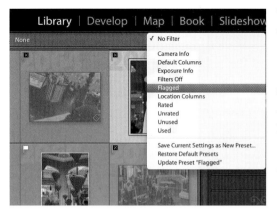

FIGURE 2.9

Select the Flagged option from the Library Filter menu.

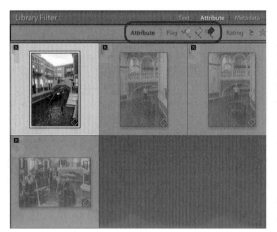

FIGURE 2.10

Clicking a flag displays the images with that attribute.

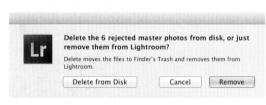

FIGURE 2.11

Deleting rejected images gives you the option of removing them from the catalog or deleting them from the disk.

The fastest way to sort your images using their new flagged status is to go to the Filter bar above the preview window, and on the far-right side of the bar click the drop-down menu labeled No Filter and select Flagged (**Figure 2.9**). This option opens a new Attributes Filter bar. Simply click the flag status that you want, and the images will be filtered and displayed in the preview area (**Figure 2.10**).

One of the main reasons I use the Rejects flag is that it makes deleting images from my catalog a snap. Once all of the flawed images have been flagged as Rejects, you can click the Photo menu and then choose Delete Rejected Photos. You can also use the shortcut keys for this command by pressing Command+Delete (Ctrl+Backspace). A dialog will then appear asking if you want to delete the images from your hard drive or just remove them from the Lightroom catalog. I don't see any reason to take up valuable hard drive space with rejected photos, so I select the Delete from Disk option, but the choice is yours (**Figure 2.11**).

The other two filtering options in the Attributes Filter bar display Flagged photos (Picks) or photos with unflagged status. As previously stated, I use the Picks flag to mark my absolute best images that I want to work with so that I can quickly filter them from the rest of the photos in the collection. This doesn't mean that I get rid of any images without a flag; it's just a method I use to sort the best from the rest. When you're done sorting, you can quickly return to an unfiltered status by clicking None in the Filter bar.

STARS AND COLORS

Although I prefer to sort using the Picks method, I sometimes like to use the star ratings and color labels as a method of sorting. These are very fast sorting tools that have shortcuts assigned to them to make your workflow move faster. To add a star rating, click an image, and then press a key from 1 to 5 to set the

star rating (pressing the 1 key assigns one star and so on). I like to use this method while previewing my images in Loupe view because it allows me to see a more detailed version of the image while applying the rating.

RATING IMAGES IN LOUPE VIEW

Follow these steps to assign star ratings to your images in Loupe view.

1. Select the first image you want to review by clicking it, and then press the E key.

2. Hold down the Shift key while pressing the desired number key that corresponds to the star rating you want for that image.

3. Press G to return to Grid view when you're done.

Holding down the Shift key while applying the rating allows you to add the star and move to the next image automatically. You don't have to do it that way, but it's a very efficient method for rating a lot of images.

Another quick method for sorting images is to assign color labels to them. Lightroom lets you use five different colors for sorting: Red (6), Yellow (7), Green (8), Blue (9), and Purple. The numbers in parentheses are the keyboard shortcuts for labeling with each color. Purple has no key assigned to it, so you'll need to use the menus to assign this color label. You can apply any label by choosing Photo > Set Color Label and then choosing the desired color. This option is also available by Control-clicking or right-clicking an image, selecting Set Color Label, and then selecting the color (**Figure 2.12**). You can also add color labels using the same sorting method as previously discussed with the star ratings: Go to Loupe view, hold down the Shift key, and press the number for the desired color label. This will assign the color label and advance to the next image.

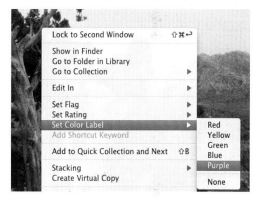

FIGURE 2.12
The Purple color label can only be added from the menu.

After you've assigned your stars and colors, you can sort your images using the same method that you used for flagged photos. Press the G key to access Grid view, click the drop-down menu on the Filter bar, and select Rated to activate filtering by stars. The default is one star with the filter set for Rating is Greater Than or Equal To. To change this setting, click the ≥ symbol to the left of the stars and change the option to Less Than or Equal To or Equal To (**Figure 2.13**). You can also use the Attribute filters to sort

FIGURE 2.13
You can change how the star ratings are sorted.

the color-labeled images just as you would the flagged and starred photos. Click the appropriate color box, and only those images will appear in the preview window.

The greatest benefit of using these sorting tools is that you aren't restricted to just one. Your images can have star ratings, color labels, and be flagged as Picks. This gives you a ton of options for sorting and narrowing down your collection of photos to just the one(s) you want (**Figure 2.14**).

FIGURE 2.14
You can filter by selecting multiple attributes.

CATALOGS AND COLLECTIONS

Throughout the chapter, you've seen the words *catalog* and *collection* pop up from time to time. The catalog refers to the entire group of images that you are working with in Lightroom, and collections let you sort your images into useful groups for quick access. You can have only one catalog open in Lightroom at a time, but you can create a multitude of collections within the catalog depending on your sorting needs.

WORKING WITH MULTIPLE CATALOGS

The first time you opened Lightroom, you were given a default catalog to work with. The catalog is where Lightroom stores all of the information about the images that you import. It doesn't actually contain the images (they live in the folder locations that you set up during import), but it is where the database of information lives for all of the photos. Anything you do to an image in Lightroom—such as adding a rating, develop settings, and keywords—and even the location of your images are saved

in this catalog. Most folks I know work in the default catalog all the time and have no need to create a new one. I also know people who create a new catalog for every shoot they do. Some folks will create catalogs every year or half year to keep catalogs organized and smaller so they are more efficient to work in.

One reason to create a new catalog is when you find that your current one becomes too slow to work in. This can happen after you have amassed several thousand images in it. Lightroom is a very fast program, but after adding about 25,000 images, it can start slowing down due to the sheer amount of information that it has to keep track of. No matter the reason for creating a new catalog, if you want to make a new one, it's a pretty easy and straightforward process.

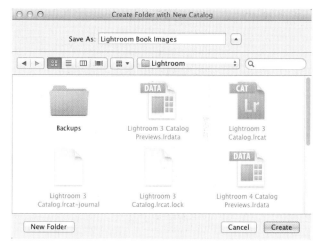

CREATING A NEW CATALOG

Follow these steps to create a new Lightroom catalog for your photos.

1. Choose File > New Catalog to open the Create Folder with New Catalog dialog.

2. Select a location and catalog name (**Figure 2.15**).

3. Click the Create button (Save button in Windows).

Once the new catalog is created, you'll see a brand-new, blank Lightroom workspace that looks just like the first time you opened the program. This is your new blank canvas for adding photos that are separate from the default catalog. You'll only be able to access new imports in this catalog; nothing from the previous catalog will be available. If at some time you need to work with images in the old catalog or another catalog that you created, choose File > Open Catalog or press Shift+Command+O (Ctrl+O). Then select the catalog you want to work with (**Figure 2.16**). The Lightroom catalogs use the extension .lrcat and should be the only files available for selection.

FIGURE 2.15
Creating a new Lightroom catalog.

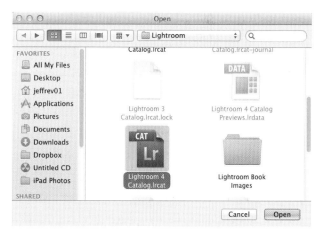

FIGURE 2.16
Select the Lightroom catalog file that you want to work with and click Open.

If you work with several different catalogs, you can choose File > Open Recent. This command shows you a list of your most recently used catalogs and allows you to select the one you want to work in. When you decide to change catalogs, Lightroom will quickly close and then reopen in the new catalog. It's just the way the application works when switching catalogs. Lightroom will display a warning screen before switching so that you know that it will relaunch with a new catalog open. You can disable this message by selecting the Don't Show Again check box.

CREATING COLLECTIONS

Probably the most popular method for grouping images is to create collections. Collections are groups of photos that you want to keep together for quick access without having to sort through everything in your catalog. How you choose to group your collections is completely up to you. The easiest way to create a collection is to choose Library > New Collection or simply press Command+N (Ctrl+N), which will bring up the Create Collection dialog. Then all you have to do is name the collection. You can also decide if you want the collection to be Top level (see "Collection sets" next) and whether or not you want to include any selected images in the new collection (**Figure 2.17**).

You have a few different ways to add images to your collections. The first is to select them all prior to creating the collection and then select the "Include selected photos" option. This will automatically add the images as the collection is created. If you want to add them after the fact or add new images to the collection after it is created, you can simply drag and drop them onto the collection title, which is located in the Collections panel on the left side of the screen (**Figure 2.18**). If you don't see your collection in the panel, click the arrow on the Collections panel to expand the panel and see its contents.

FIGURE 2.17
The Create Collection dialog.

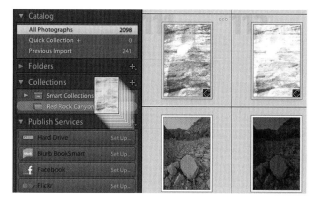

FIGURE 2.18
You can drag and drop images directly on a collection title to add them.

COLLECTION SETS

Sometimes you might want to group similar collections to help keep your images organized. This can be very handy as you start to accumulate many collections. To do this, you can create Collection Sets. A Collection Set is nothing more than a collection of collections. So, for example, if I had several different landscape shoots, I might want to create a top-level collection called Landscapes. Then I could put all of my different landscape collection shoots within this set. It's just a nice way of organizing your groups of photos.

You can create a set by choosing Library > New Collection Set or by clicking the plus (+) symbol on the Collections panel and then choosing Create Collection Set from the pop-up menu (**Figure 2.19**). When the dialog opens, type the name for the set and click the Create button (**Figure 2.20**). To add previous collections to the new set, simply click and drag the set title in the Collections panel onto the new Collection Set title. You can also add new collections to the set using the New Collection dialog: When you're creating a new collection, change the Placement option from Top level to Inside a Collection Set, and then choose which collection you want it included in (**Figure 2.21**).

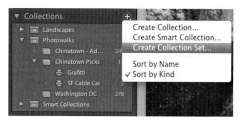

FIGURE 2.19
You can create a Collection Set by clicking the plus (+) symbol.

FIGURE 2.20
Name the new Collection Set.

FIGURE 2.21
New collections can be added to an existing Collection Set.

When you click on a collection, the preview screen will display only the images that are included in that collection. These will be the only images visible in the filmstrip at the bottom of the program interface as you move from module to module. To access all of your images again, press L to make sure you are in the Library module, go to the Catalog panel, and then select All Photographs (**Figure 2.22**).

FIGURE 2.22
Select All Photographs to display the contents of your entire catalog.

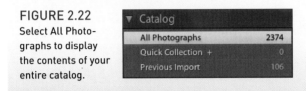

SMART COLLECTIONS

Smart Collections are like collections on autopilot. Some default Smart Collections are already set up for you, and some are created as you tag your images with stars or colors. Some of the default Smart Collections include Past Month, Recently Modified, Video Files, and Without Keywords. As you can see, it's pretty easy to figure out what criteria the collection is using to gather images. To create your own Smart Collection, choose Library > New Smart Collection or click the plus (+) symbol on the Collections panel, and then choose Create Smart Collection from the pop-up menu.

The Smart Collection dialog lets you configure any number of filters so that your collection can contain a broad range of images, like File Type is JPEG, or a very specific range, like label color is Red, keyword is Nevada, and the camera aperture is f/2.8 or larger (**Figure 2.23**). You can add more specific filters to exactly target those images that you want.

I use Smart Collections all the time to make quick groups of images for my books. I first create a new Smart Collection using the criterion "Label Color is Blue." Then I start looking through my catalog of images for shots that I think will work well as illustrations in my book. When I find a shot, I select it and press the 9 key to assign a Blue label to it. I continue doing this as I sort through my images until I think I have what I need. Then I access my Collections panel and look at my Smart Collection for Blue labels. All of the photos that I want to work with appear in that collection. There's no need for me to drag them into the collection because the simple act of labeling them automatically adds them to the collection. It really is a super fast way to group images together.

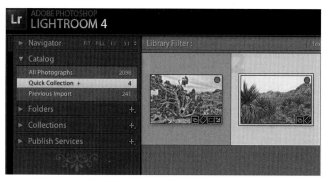

FIGURE 2.23
You can add your
own rules to
customize a Smart
Collection.

QUICK COLLECTIONS

At times you'll need to make a small collection of images that you'll need only for a
short period of time, so creating a collection might be a little too much effort. A per-
fect example would be those times when you want to send a group of photos in an
email, but they first need to be adjusted in the Develop module. In those instances,
you could put them into a Quick Collection. To do this, select the images that you
want to add and press the B key. There is only one Quick Collection. So, to see the
images that you have added to it, access the Catalog panel and click Quick Collection.
This will filter out all other images and display only those items you have added to
the collection. You can tell an image is part of the Quick Collection because it will
have a dark circular mark in the upper-right portion of the thumbnail (**Figure 2.24**).
When you are finished with the images, all you have to do is select them and press
the B key once more to remove them from the Quick Collection.

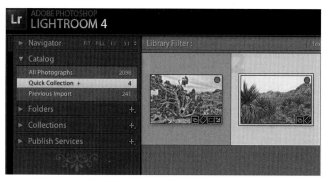

FIGURE 2.24
Press the B key to add images
to the Quick Collection.

USING FILTERS TO FIND PHOTOS

I've covered several tools to help you categorize and group images to be able to find them later when you need them, but sometimes the photo you want is the one that you didn't add to a collection or assign a keyword. Fear not; you can still narrow down your search using the Library Filters. I've already discussed the Attributes filters, which allow you to filter by star ratings, color labels, and flagged status. However, there are a couple of other Library Filters that you may also find handy for searching your catalog.

TEXT AND METADATA FILTERS

The Text filter looks at all of the word-based information associated with your images to help you filter and locate them. Selecting the Text filter option allows you to set certain variables used by the filter. The first option sets where you want the filter to look. It is set to Any Searchable Field by default, but you can narrow it down to more specific locations, such as filenames, captions, metadata, and so on. The second option sets the inclusion/exclusion variables, like contains, or starts with, or contains all. Just choose the one that is appropriate for your search. With the Text filter, you can also type the text you want to look for in the searchable text field. For example, if I wanted to find images that I knew were in a folder called New Orleans but forgot to keyword them, I'd just need to set my Text filter to Any Searchable Field > Contains > New and the filter would locate all the images in the New Orleans folder (**Figure 2.25**).

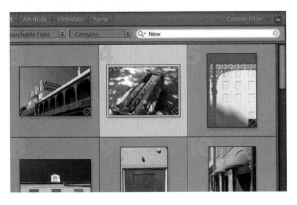

FIGURE 2.25
Typing the word New in the Text filter pulled up these images from my New Orleans folder.

If you really want to get in the weeds, nothing beats the Metadata filter. You can set up numerous searchable fields to home in on the images you want. For example, if I needed to find a shot for one of my books that was taken with my Nikon D7000, at a high ISO, with a lens focal length of 17mm, and had a portrait orientation, I could perform that search with the Metadata filter and find all the images that met those criteria (**Figure 2.26**).

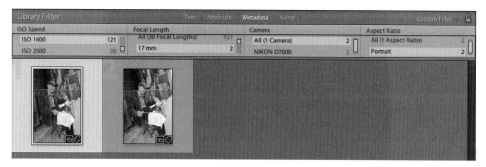

FIGURE 2.26
You can sort by any number of criteria using the Metadata filter.

To change the metadata search fields, click the name of the search field in the title for each column to bring up the searchable items list (**Figure 2.27**). Select the metadata attribute that you want to use. Then select the exact item for that attribute, for example, ISO 1600. Do that for as many different search items as you want to use, and the results will appear in the preview window below the Library Filter.

CHANGING VIEW OPTIONS IN THE LIBRARY

Thus far, you have been looking at images using the Grid view, which is also referred to as the thumbnail view. You can switch to Grid view at any time by pressing the G key. In fact, pressing the G key will move you out of any of the other modules, like Develop or Print, and bring you to the

FIGURE 2.27
The Metadata filter selection menu.

Library module. While in Grid view, you can see an enlarged view of your selected image by pressing the E key to enter Loupe view. This is not a 100 percent view, but it does fill the image preview section with a single image view, which is usually large enough to do most editing work (**Figure 2.28**).

FIGURE 2.28
The Loupe view dis-
plays a large image
preview.

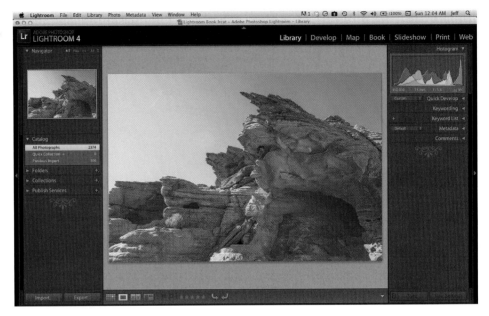

You can also put an image into Loupe view by pressing the Enter key or by double-clicking the thumbnail. To move between images while in Loupe view, press the left or right arrow keys. You can also use the Filmstrip view below the preview window to move quickly between images. I usually have the Filmstrip view in auto-hide mode so that it only appears when I move my mouse to the bottom of the screen.

TIP

The thumbnails in Grid view can be resized by adjusting the slider located in the bottom-right portion of the preview window.

ZOOMING IN

Sometimes the Loupe view is not sufficient, and you'll need to see a zoomed in version of the image. Zoom view is handy for looking at fine details when sharpening an image or looking for dust spots.

To quickly zoom into an image, just press the Z key. You can also zoom in by pressing the Enter key twice in Grid view or once in Loupe view. Or, click once on the image in Loupe view to enter Zoom view or twice while in Grid view. When the image is in

Zoom view, your cursor will look like a hand and you'll be able to move the image around to look at different parts. You can also use the Navigator panel to move around the image as well as change the Zoom view (**Figure 2.29**). A rectangle will appear in the panel to show you where you are looking in the preview area. You can move this rectangle around as well to see different parts of the image. Different view magnification shortcuts are provided at the top of the panel. Just click Fit, Fill, 1:1, or 3:1 to change the magnification. You can also change the 3:1 setting to a different ratio by clicking the up and down arrows to the right of 3:1 and then selecting a new ratio from the pop-up options.

FIGURE 2.29

The Navigator lets you see which area is being displayed in the Zoom view.

MAXIMIZING YOUR SCREEN VIEW

If you really want to get the most out of your Loupe view, try hiding one or both of your side panels when you aren't using them. You can quickly hide both panels by pressing the Tab key. If you need to keep one of the panels open, try clicking the outward facing arrow on the far left or right side of the screen. This will hide the panel and put it into an auto-hide mode. That means it won't appear until you slide your mouse to the far edge of the screen, which will make the panel pop back into view. If you want to turn off auto-hide mode, just click the side arrow again. You can quickly tell if the panel is in auto-hide mode because the arrow will look like it is made from small dots and will be solid when it is turned off.

TURN OUT THE LIGHTS

Sometimes all of the panels and menus can be a distraction when viewing your images. If you want to isolate the image, press the L key to turn on Lights Out mode. Pressing L once will darken everything but the preview window. Press L again and everything will go black except your photo. Press L once more to return to normal view. You can use the left and right arrow keys to change images in the view while in Lights Out mode.

COMPARING IMAGES

If you want to do side-by-side comparisons of your images, you can use Compare view. Just select two images from the Grid or Filmstrip, and then press the C key. Your images will be placed beside one another for you to compare. This mode works fairly well, but my favorite way of narrowing down a selection of images to just a few is by using a method that my friend Scott Kelby taught me. Here's how it works.

1. Create a collection containing all of the images that you want to work with.

2. In Grid view or Loupe view quickly select the better images in the collection by using the P key to flag them.

3. After you've flagged all of the better photos, access the Attributes filter and click the "Filter based on flagged status" option.

4. Now that you have a smaller group of good images, select the first eight and press the N key to enter Survey view.

5. Review each image and decide whether to keep or remove it. To eliminate it from Survey view, click the X on the image or Command-click (Ctrl-click) on the thumbnail.

6. When you've narrowed down the selection to your best images, press the G key to return to Grid view. The images that were in Survey view will automatically be selected when you return to Grid view. Press the 5 key to assign a 5 star rating to them.

7. Select the next group of eight images and repeat steps 5 and 6. Do this until you have selected and surveyed all of the flagged images.

8. Return to the Library Filters and click on the 5 star filter attribute to narrow down the photos to just the flagged images with 5 stars.

9. Press Command+A (Ctrl+A) to select all of the remaining images.

10. Press Command+N (Ctrl+N) to create a new collection and name it [*active collection name*]+Picks (**Figure 2.30**).

11. Make sure that Placement is set to Next to Collection, select the "Include selected photos" check box, and then click Create.

You now have a collection of your best images from the photo shoot. It seems like a lot of steps, but after you go through the process once or twice it will become second nature. It will also enhance your ability to sort through lots of images and narrow them down to your very best work.

FIGURE 2.30
After sorting, the best images are now in their own collection.

Chapter 2 Assignments

Here are a few exercises to help you practice different techniques to organize your photos.

Become Familiar with the Library

Your sorting and tagging tasks will be easier if you are comfortable with how your workspace is organized. Adjust your thumbnails so that you can see them clearly. In Loupe view use the left and right arrow keys to review your images. If you want to remove the panels, press the Tab key to slide them out of the way.

Keywords Are the Key

Look at some of your images in Grid view and see if they have some qualities in common. Create a keyword and tag these images. Remember that you can use multiple keywords on one image. After you have assigned a few different keywords, isolate those images in the preview window by selecting the arrow next to the keyword in the Keyword List.

Time for Some Collections

Remember that keywords and collections are different yet very similar. Create a collection called Email and add some photos to the collection that you can send to family and friends. (If you aren't sure how to email photos quite yet, don't worry. You'll learn how in Chapter 8.)

Sort Some Images

If you've spent time tagging your images with keywords and flags, it's time to do some sorting. Use the Library Filters to sort your picks. Try flagging your rejected images so that you can remove them from the catalog. Try sorting with the Metadata filters. Playing with the different sorting and filtering options is the best way to learn how to use them. Don't worry; you won't hurt any of your images by filtering them.

Share your results with the book's Flickr group!

Join the group here: flickr.com/groups/photoshoplightroomfromsnapshotstogreatshots

3

ISO 400
1/125 sec.
f/13
105mm lens

The Develop Module

MAKING IMAGES LOOK A WHOLE LOT BETTER

Now that you've imported your images and have sorted them in an orderly fashion, it's time to look at some solutions for making them look better. The Develop module contains just about every tool you'll need to make your images look their best. It's probably where you will spend the majority of your time, and as you become more familiar with the tools and panels, your ability to quickly process any image will greatly improve. Of course, the best images start in the camera with the best settings, which is why I'll start off with a word about shooting raw.

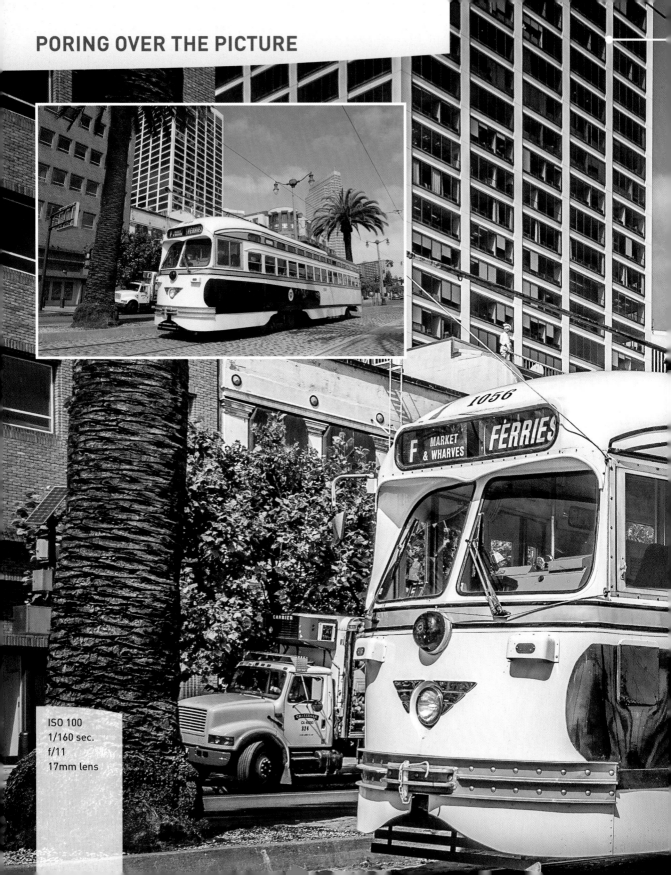

ISO 100
1/160 sec.
f/11
17mm lens

The perspective was corrected using the Vertical slider in the Manual section of the Lens Correction panel.

By increasing the blue Saturation and lowering the Luminance slider, I enhanced the blue skies.

Post-Crop Vignetting was used to darken the edges of the frame.

I added a lot of Clarity to really punch up the mid-tone contrast.

Kansas City

Last fall I spent some time walking around the waterfront area in San Francisco near the Embarcadero. It's a great location for photography, and it's where I found this awesome-looking streetcar. I don't know if it was still in use or was just there as an historic display, but either way it was a photo-op I just couldn't pass up. It was a bright, sunny morning when I took the photo, but the image that came out of the camera was not nearly as vivid as what I wanted, so I turned to the Lightroom Develop module for a little help.

WHY YOU SHOULD BE SHOOTING RAW

Most likely, your camera offers different image formats for storing the pictures on the memory card. JPEG is probably the format that is most familiar to anyone who has been using a digital camera.

There is nothing wrong with JPEG if you are taking casual shots. JPEG files are ready to use right out of the camera. Why go through the process of adjusting raw images of the kids opening birthday presents when you are just going to email them to grandma? And JPEG is just fine for journalists and sports photographers who are shooting nine frames a second and need small images to transmit across the wire. So what is wrong with JPEG? Absolutely nothing—unless you care about having complete creative control over all of your image data (as opposed to what a compression algorithm "thinks" is important).

To give you a little background, JPEG is not actually an image format. It is a compression standard, and compression can cause problems in images, such as artifacting and detail clipping. When you set your camera to JPEG—whether it is set to High or Low compression—you are telling the camera to process the image however it sees fit and then throw away enough image data to shrink the image to a smaller size and take up less space. In doing so, you eliminate subtle image details that you will never get back in postprocessing. Although that is an awfully simplified explanation, it's still fairly accurate.

SO WHY RAW?

First and foremost, raw images are not compressed. (Some cameras have a compressed raw format, but it is lossless compression, which means there is no loss of actual image data.) Also, raw image files require you to perform postprocessing on your photographs. This is not only necessary, but it is the reason that most photographers use the raw format.

Raw images have a greater dynamic range than JPEG-processed images. This means that you can recover image detail in the highlights and shadows that just isn't available in JPEG-processed images.

A raw image is a 14-bit image, meaning that it contains more color information than a JPEG, which is almost always an 8-bit image. More color information means more to work with and smoother changes between tones—similar to the difference between performing surgery with a scalpel as opposed to a butcher's knife. They'll both get the job done, but one will do less damage.

A raw image offers more control over sharpening, because you are the one who is applying it according to the effect you want to achieve. Once again, JPEG processing applies a standard amount of sharpening that you cannot change after the fact. Once it's done, it's done.

Most important, a raw file is your digital negative. No matter what you do to it, you won't change it unless you save your file in a different format. This means that you can come back to that raw file later, try different processing settings to achieve various results, and never harm the original image. By comparison, if you make a change to your JPEG file and accidentally save the file, guess what? You have a new original file, and you can never revert to that first image. That fact alone should make you sit up and take notice. This doesn't mean that you should never shoot JPEG photos; rather, just be aware of the differences between JPEG and raw as you start working on photos in the Develop module.

THE DEVELOP MODULE ADJUSTMENT TOOLS

To work on an image in the Develop module, click the word Develop at the top of Lightroom or simply press the D key. Eight different panels are located on the right side of the Develop module. Each one contains a variety of controls that enable you to make specific adjustments to your image. You will probably do most of your work in the Basic panel (**Figure 3.1**).

FIGURE 3.1
The Basic panel.

THE BASIC PANEL

A raw image file contains no adjustments when it comes out of your camera. It does, however, contain the metadata that stores the camera settings used to create the image. This includes aperture, ISO, and shutter speed settings. It also includes the camera's white balance information, which is what appears in the White Balance control.

GETTING THOSE COLORS RIGHT

The default White Balance setting is As Shot, but you can change that to several different presets, just as you would on your camera. Included in the list of presets are Auto, Daylight, Cloudy, Shade, Tungsten, Fluorescent, Flash, and Custom (**Figure 3.2**).

FIGURE 3.2
Raw shooters can select different White Balance presets.

Selecting one of these presets will change the Temperature and Tint settings of the image to the preset value. If you do this manually by using one the sliders below the White Balance presets, the White Balance setting will be set to

Custom. If you have something in your image that is neutral in color, you can click on it with the White Balance Selector (the eyedropper) and automatically adjust the white balance. This is also helpful if you have included a white balance card in one of your images, because you can use it to correct white balance in a group of photos taken in the same lighting conditions.

Ideally, you should include a new white balance shot for every changing light situation you are shooting in. If you have not included a white balance card in your image, start with a preset that closely matches the light that your photo was taken in. If the white balance still needs a little adjusting, fine-tune it with the Temperature slider until it looks right. The goal is to remove any color cast in your image and make the colors look as they should.

NOTE

A *color cast* is a tint of color that affects the entire image and is usually undetected by the human eye but can be captured by your camera. For example, a blue sky will cause objects in a shaded location to have a blue color cast.

MAKING TONAL CORRECTIONS WITH THE EXPOSURE SLIDER

Once you have adjusted the image's white balance, it's time to start correcting the overall brightness and darkness. A good reference for what to adjust is in the histogram in the upper-right corner of your screen. A *histogram* is a graphical representation of the tones in your photo; the darkest areas are on the left, and the brightest parts are on the right. If your image is overexposed or has areas that are so bright that they appear as white and have no visual information, the histogram will have a spike on the right side. If there is a lot of black in the photo, the histogram will have a large spike on the left side. The key is to make sure that you have good tones throughout the image and that the blacks and whites are as accurate as possible. The easiest way to do this is by adjusting the Exposure sider.

If you need to make overall adjustments to the image brightness, you can do so by moving the Exposure slider, which has a default setting of 0. The adjustments are related to stops in exposure value. You can make the image five stops brighter by moving the slider to the right or five stops darker by moving it to the left.

CHECK YOUR CLIPPING WARNINGS

The histogram displays triangles in the upper-left and upper-right corners of the graph. These are your clipping warning indicators. *Clipping* is when an area of the photo is either so dark or so light that it no longer contains any detail and appears as black or white in the photo. When this happens, the small triangles will turn white (**Figure 3.3**). If you want to see where clipping is occurring in the photo, click the white triangle and a color overlay will appear on your image in the offending area (red for overexposed and blue for underexposed). Depending on the amount of clipping, you might be able to correct the exposure to bring details back into your image.

Remember that sometimes black is black and white is white. That is, there might be areas in your image that contain some clipping but do not need to be corrected. If the sun is in your shot, no amount of image adjustment will get rid of the clipping warning, so decide just how much effort you need to apply to fix the problem.

FIGURE 3.3
The clipping warning indicates where your highlights and shadows need adjusting.

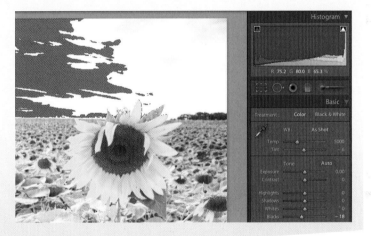

ADJUSTING IMAGE CONTRAST

The Contrast slider is set to 0 by default, and moving it to the right increases the contrast in your image. A contrast increase means that you will have a decrease in the amount of midtones of the image, making them either darker or lighter. By lowering the adjustment (moving the slider to the left), you increase the midtones by making dark areas lighter and light areas darker. Adding contrast often adds some visual impact to the image, but you should be careful not to go overboard. Sometimes a subject looks better with a flat contrast. For example, a gray, overcast day is low contrast, and a bright sunny day is high contrast. Each look can be appropriate at times in your photos.

SAVING YOUR HIGHLIGHTS

The Highlight slider is an amazing tool for fixing those areas in your photo that are too bright without making the rest of the image darker. As you move the Highlight slider to the left, the brightest parts of the photo get darker and darker. The best way to use this tool is to watch the highlight clipping warning in the histogram (Figure 3.3). You can continue moving the Highlight slider to the left until the warning disappears. An easier way to do this is to click the highlight warning triangle and then move the Highlight slider to the left until the red overlay on the image disappears.

If you aren't clipping highlights but find that they need a little brightening, simply move the Highlight slider to the right.

> **TIP**
>
> You can quickly turn on the overexposure and underexposure warning overlays on your image by pressing the J key.

LIGHTENING YOUR SHADOWS WITH THE SHADOW SLIDER

If you have the opposite problem of too many dark areas with no detail, you can try using the Shadow slider. This slider was called Fill Light in previous versions of Lightroom. Moving this slider to the right lightens the darkest parts of your image without affecting the highlights. The slider can be adjusted to a setting of 100, but it usually isn't necessary to move it more than 20 points to fix most problems. You can also move the slider to the left if you want to darken the shadow areas with minimal effect on the midtones and highlights.

BETTER-LOOKING BLACKS

The Blacks slider works specifically on the darkest parts of the image. Sometimes it's necessary to increase the blacks, especially if you made a lot of Shadow modifications. Moving the Blacks slider to the left inceases the black/dark areas of an image and adds some contrast and a little increase in color saturation. Moving the slider to the right lightens the blackest parts of the image. The Blacks slider does not have much effect on the midtones or brightest tones in the image.

FINE-TUNING YOUR WHITES

Another change in Lightroom 4 is the addition of the Whites slider, which replaces the Brightness slider in previous versions. The Whites slider acts in the same fashion as the Blacks slider, but it affects the brightest parts of the image without touching the midtones and blacks.

ADDING SOME VISUAL PUNCH WITH THE CLARITY SLIDER

Of all the sliders in the Basic panel, the one I always use is Clarity. This adjustment adds contrast to the midtones in a way that can punch up a dull image or soften an image that looks too crisp. The default setting for this adjustment is 0; moving it to the right increases midtone contrast and makes the image look crisper and snappier. Moving the slider into the negative numbers decreases the midtone contrast and gives the image a softer look. This is a great way to improve skin tones in a portrait. The best way to make Clarity adjustments is to zoom your image to a 100% view so that you can better judge the effects of the slider.

BRIGHTENING DULL COLORS

The Vibrance slider lets you make adjustments to the less colorful parts of your image. By moving the slider to the right, the saturation of less colorful areas increases without affecting the already saturated areas. The algorithm that controls the adjustment was written so that skin tones are not as affected by the increase of saturation. You can also get a more subtle palette of colors by reducing the vibrance of the image.

FROM BLACK AND WHITE TO CRAZY COLORS WITH SATURATION

If you want to boost all the colors in your image, use the Saturation slider. Moving it to the right increases the saturation of all colors in the image. Moving it to the left decreases saturation all the way to the point of looking like a black-and-white image.

THE TONE CURVE PANEL

Although contrast adjustments are available in the Basic panel, it's sometimes necessary to have a little more control over which areas of contrast are affected. This is where the Tone Curve panel comes into play. The four sliders can be adjusted to the right for lightening or left for darkening (**Figure 3.4**). The top slider is for highlights, which are the brightest parts of the image. The Lights slider works on the brighter tones without affecting the highlights or darker areas. The Darks slider affects darker portions of the image without affecting the lights and highlights. The Shadows slider works on just the darkest

FIGURE 3.4
The Tone Curve gives you more control over image contrast.

portions of the image (**Figure 3.5**). If you don't want to use the sliders, you can try using the Target Adjustment tool. To activate it, click the small circular bullseye to the upper left of the Tone Curve graph. You can also press Command+Alt+Shift+T (Ctrl+Alt+Shift+T). When the tool is active, place the cursor on the area of the image that you want to change, and then click and drag your mouse. Moving the mouse up lightens the area; moving it down darkens the area. When you're finished, click Done at the bottom of the preview window.

shadows darks lights highlights

FIGURE 3.5
Tonal regions are controlled by the different curve sliders.

ADJUSTING COLORS

The White Balance tool in the Basic panel allows for color corrections, but what if you want to make changes to a particular color in the image? If that's the case, you need to check out the HSL/Color/B&W panel.

HUE, SATURATION, AND LUMINANCE

This HSL/Color/B&W panel is divided into three sections. To activate the Hue, Saturation, and Luminance tools, click HSL in the panel's title bar. The HSL panel (**Figure 3.6**) is divided into four sections with the first being Hue. The Hue sliders allow you to make modifications to the actual colors. If you want your yellows to look greener, move the slider to the right. If you want them to look more orange, move it to the left. These color shifts are fairly subtle and are for fine-tuning your colors on an individual basis.

FIGURE 3.6
The HSL panel adjustment sliders.

If you want to adjust the saturation of a color, click the word Saturation to switch to that portion of the panel. These sliders allow you to increase or decrease the saturation, or how vivid the individual colors appear. You can actually move a slider all the way to the left to turn a color gray, which is handy for applying some special effects to your images.

The Luminance sliders darken or lighten a specific color in the image. They don't affect the vividness, just how bright or dark the color is.

If you want to see all three of the adjustment tools in one panel, click the word All for an expanded panel view (**Figure 3.7**).

FIGURE 3.7
Expand the HSL panel to see all the sliders by clicking All.

COLOR PANEL

The Color panel is another way of making HSL changes using a different format for the adjustment. You can click a color block at the top and then use the Hue, Saturation, and Luminance sliders below to make your changes (**Figure 3.8**).

CREATING GREAT BLACK-AND-WHITE IMAGES

Clicking the B&W adjustment panel will instantly turn your image to a black-and-white version. Lightroom renders an auto-conversion, which is why the sliders are not set to 0. I find that the auto-conversion is not as good as one that I adjust myself, so I reset the sliders to 0 by double-clicking each color name. Then I move each slider while looking at the image to get the desired tonal effect. The sliders work by targeting individual colors and adjusting their gray values in the image. This means that if you have a blue element in the image, like the sky, you can move the Blue slider to the left to darken just those areas that are blue (**Figure 3.9**).

FIGURE 3.8
The Color panel makes adjustments similar to the sliders in the HSL panel.

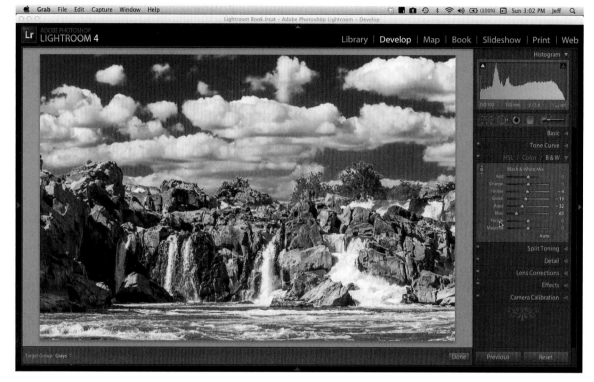

FIGURE 3.9

Adjust the color sliders to make a great looking black-and-white image.

Another favorite method for adjusting the tones in an image is to use the Target Adjustment tool, like you did in the Tone Curve panel. Activate the tool by clicking the little bullseye in the panel or by pressing Command+Alt+Shift+G (Ctrl+Alt+Shift+G). When the tool is activated, just drag it on areas of the image that you want to lighten or darken, and the tool will automatically make those changes to the different sliders based on the underlying color you are sliding the cursor over.

CREATING SPLIT TONES

Split Toning is a way to add color hues to the highlights and shadows of your black-and-white photos. It is a look that dates back many decades and is probably most famously known by the name sepia tone. Using the Split Toning tool is very simple. After adjusting your image to make it black and white, select the desired Hue that you want for the highlights, shadows, or both, and then increase the Saturation to control how much color toning is introduced. You can also use this panel on color images, but it's much more effective in black and white (**Figure 3.10**).

FIGURE 3.10
Split Toning can add
some great color
effects to black-
and-white photos.

ALL RAW FILES NEED SHARPENING

When you click the Detail panel, you'll see that some base sharpening has already been applied to your photo. The reason is that raw images do not have sharpening added by the camera, like JPEGs do, so Lightroom adds a little bit to get you started. If you are working with JPEG images, the files will have zero sharpening applied as a default. Once again, the reason is that your camera has already applied sharpening when creating the JPEG file, and Lightroom does not want to oversharpen your images.

APPLYING SHARPENING

When applying sharpening, you should first zoom in to a 100% view so that you can see the precise results of your sharpening efforts. Then raise the Amount slider to a level that provides good detail to sharpen edges in the image. The goal of sharpening is to make the edges look better without affecting the elements that shouldn't be sharp, like the sky, skin, or a flat surface. Typically, you'll get the best results with the Amount slider set somewhere between 50 and 100.

The Radius slider controls how much the sharpening extends out from the edges. The default setting is 1; I leave it set there most of the time. If you have an image that looks fuzzy, you can try raising this slider a bit, but be careful not to go overboard.

The Detail slider is set to 25 by default, and that is generally where I leave it. You can raise it if you want to increase small details, like intricate lines. When using this slider, avoid introducing halos. If you move the Detail slider too high, you'll get contrast lines around your edges that can look like glowing halos. If you start seeing them, lower the Details slider until they disappear.

The Masking slider is one of my favorites. It allows you to mask out or restrict the sharpening to only the edge areas of the image and avoid the surfaces. Using the slider is as simple as moving it to the right, but it can be difficult to see the results, which is why I prefer to use a visual helper. Hold down the Option (Alt) key while dragging the slider, and a black-and-white mask will appear on the image in the preview window. At first the window will appear completely white, but as you move the slider to the right, you'll see portions of the image turn black (**Figure 3.11**). Keep moving the slider until just the edges that you want sharpened are white, and everything else is black.

FIGURE 3.11
Hold down the Option (Alt) key while moving the Masking slider to see where sharpening is being applied.

If you aren't sure where to start with your Sharpening settings, try these: Amount 70, Radius 1.0, Detail 30, and Masking 70. Then move the sliders and fine-tune for your image. It's important not to oversharpen your photos. A sharp image with good details is great, but an image that is oversharpened will stick out like a sore thumb.

TAMING THE NOISE

Sometimes it's necessary to shoot with a high ISO, even though you know it will add digital noise to your image. When this happens, you can turn to the Noise Reduction sliders to help eliminate the problem. Most noise you will encounter can be handled by adjusting the Luminance slider. All that's required is to move the slider to the right until the noise in your image is gone. Too much noise reduction can make your picture look soft, so don't overdo it. The default settings for the Detail and Contrast sliders are usually adequate for most situations, but you can fine-tune them after reducing the noise with the Luminance slider. You might find that you need to readjust your Sharpening settings after applying noise reduction.

The Color slider is set to a default of 25 and rarely needs to be adjusted. If you are still seeing small multicolored specks in your image, move the Color slider to the right until they are gone (**Figure 3.12**).

FIGURE 3.12
Adjust the Luminance slider to reduce image noise.

LENS CORRECTION

When you take a photograph, it's sometimes easy to forget how much curved glass the light is passing through in the lens to make the image on the sensor. All that glass can have some negative effects in your image in the form of distortion and vignetting. If you are shooting raw images, there's a good chance that Lightroom will be able to automatically correct those problems by using Lens Profiles. By selecting the Enable Profile Corrections check box, Lightroom will look at your image metadata to determine the lens make and model, and then match it to one of the presets (**Figure 3.13**). If you shot JPEG, you can try to locate the lens by manually selecting items in the Make, Model, and Profile drop-down lists. **Figure 3.14** shows an uncorrected image on the left with dark vignetting on the corners and some barrel distortion or curving of straight lines. The image on the right has had the corrective profile applied, which has improved those problems.

FIGURE 3.13
Select the Enable Profile Corrections check box to activate auto-lens correction with Lens Profile presets.

FIGURE 3.14
The figure on the left has line distortion and dark vignetting in the corners. The image on the right has been corrected using auto-lens correction.

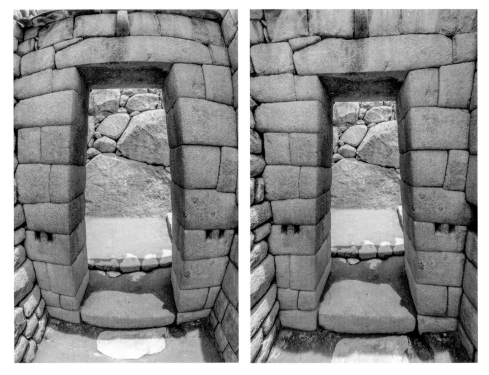

If you can't find your lens in the list, access the Manual adjustments and manually make changes to correct problems like distortion and vignetting.

ADDING SOME EFFECTS TO YOUR IMAGE

Vignetting that comes from your lens can be a problem, which is why there is a correction for it. But when you want vignetting in your image, it's called an effect. Vignetting is a very popular effect that you'll see in all sorts of photos. It is a way of darkening or lightening the edges/corners of an image to draw the viewer's eyes in towards the center of the frame and the subject (**Figure 3.15**). Using the sliders in the Effects panel to create a vignette is pretty easy. Just move the Amount slider to the left for a dark vignette and to the right for a lighter effect (**Figure 3.16**). You can control how far into the image the vignette extends by using the Midpoint slider. Using the Roundness slider you can make the vignette pattern appear more rounded by moving it to the right or a little more squared off by moving it to the left. The Feather slider controls how soft the fall-off is between the vignette and the image. The Highlights slider lets you protect light areas from the effects of the vignette. So, for example, if you are vignetting a landscape that includes a sky and you want the majority of the vignette only on the darker ground area, you could move the Highlights slider to the right and recover the brightness in the corners of the lighter-colored sky.

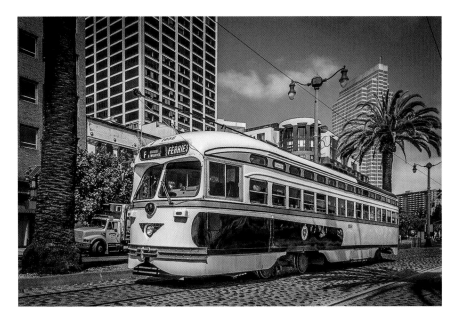

FIGURE 3.15
Edge vignetting was added to this image using the Effects panel.

FIGURE 3.16
The Effects panel lets you add vignetting and fake film grain.

The Effects panel also contains a Grain effect that introduces film-like grain in your image. This is different than noise and is mostly used to give images an older vintage look.

THE CAMERA CALIBRATION PANEL

Have you ever looked at the image on your camera's LCD screen and thought, wow, this looks great! and then when you look at it on your computer screen, it's a little disappointing? You've probably experienced this if you shoot raw, because the image you see on your camera is a JPEG that has been corrected and enhanced by the camera. But because you are working with a raw file, all of those enhancements are stripped away when you open it on your computer. A quick way to add back some of that pizzazz is to select a new camera profile from the Camera Calibration panel.

IMPROVING YOUR IMAGE WITH CAMERA PROFILES

Camera profiles are settings that attempt to match the camera manufacturer's colors in different shooting scenarios. The Adobe Standard profile is the default setting for all raw files. It is fairly generic and treats all raw files the same way, no matter which camera produced them. It is simply a base enhancement to improve color rendering in the yellows, reds, and oranges of your image.

Camera profiles are specific to your camera and often contain choices, such as Camera Standard, Landscape, Vivid, Portrait, and Neutral, but each might be slightly different for your camera make and model (**Figure 3.17**).

Using the profiles is as easy as selecting a new profile from the drop-down menu. You will get an instant preview in the main preview window. There's no way of knowing which profile will look best, so it's best to try them all. I find I get the best results with the Landscape and Vivid profiles. They can be a little contrasty, though, so I don't necessarily use them all the time. It really depends on the subject.

FIGURE 3.17
Camera profiles can easily be changed in the Camera Calibration panel.

By the way, if you shoot JPEG, you will not be able to use any of the presets on this panel. In fact, if you have a JPEG loaded and click the Camera Calibration panel, the only profile that appears is Embedded, which means that your image already has a profile assigned to it by the camera.

DEVELOP PRESETS

One way you can greatly improve the speed with which you process your images is through the use of presets. Lightroom comes loaded with some built-in presets for your use, but you can also create your own custom presets tailored to the way you process images.

USING AND PREVIEWING DEVELOP PRESETS

The Preset panel is located to the left of the preview window, just under the Navigator panel. I like to combine the use of these two panels when working with presets because the Navigator allows me to quickly preview the look of a preset without having to apply it to my image. The Preset panel is very simple to use; just expand one of the preset groups and then move your mouse over a preset. The preset look will immediately be displayed on your image in the Navigator panel. You can quickly move your mouse over the presets and preview the effect until you find just the right one. Then all you have to do is click the preset name, and Lightroom applies it to the image in the preview window (**Figure 3.18**).

FIGURE 3.18
You can quickly preview a Develop preset by moving your mouse over the preset name and viewing it in the Navigator.

CREATING CUSTOM PRESETS

You can create customized presets to help you speed up your image processing by applying image corrections that you use over and over again.

1. Select a typical image that you would process, and then press D to access the Develop module.

2. Apply all of the corrections and adjustments to the image that you normally would, like Camera Calibration, Detail sharpening, and Basic Develop settings.

3. When you're done, click the plus (+) symbol at the top of the Preset panel to open the New Develop Preset dialog.

4. Name your preset and set the location (I use the default User Presets folder).

5. Deselect any Develop settings that you do not want included in the preset. You can also click the Check None button and then go back and select those you want to include (**Figure 3.19**).

FIGURE 3.19
The New Develop Preset dialog lets you customize which settings will be applied in the preset.

6. Click the Create button, and then look in the Preset panel under the User Presets for your new custom preset.

Your preset will act just like those built into Lightroom, and you can see a preview of it in the Navigator panel when you hover your mouse over the preset name. Click to apply the preset to your image. You can also use these presets during the import process, as discussed in Chapter 1.

GO BACK IN TIME WITH A SNAPSHOT

If you'll be doing a lot of work on an image, you might want to create some snapshots along the way. A snapshot is like a bookmark in that it will take you back to a specific point in your image processing. So, if you've done some basic processing of your image and you want to try some special effects, you can create a snapshot and then proceed with your processing. If at any time you want to revert to the saved version, you can just click the name in the Snapshots panel and you are instantly transported back to that saved point. Snapshots can also be handy if you want to create several different versions of your image using Virtual Copies (see the section "Virtual Copies and Image Stacks" later in this chapter).

To create a snapshot, find a point in your processing that you want to save and then click the plus (+) symbol on the Snapshots panel title bar. Enter a name for your snapshot, and then click the Create button (**Figure 3.20**). When you hover your mouse over the snapshot, the same image will be displayed in the Navigator panel (**Figure 3.21**).

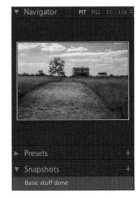

FIGURE 3.20
Creating a snapshot of your image allows you to go back to a specific point in the develop process.

FIGURE 3.21
Your new snapshot will be available in the Snapshots panel.

A QUICK HISTORY LESSON

Because Lightroom is essentially a database, it is very easy for it to keep track of everything you do to an image while working in the Develop module. These processing changes are tracked in the History panel. The first item in the panel is usually the image import. If you move your mouse over this entry, you'll see a preview of how your image looked at that point in the Navigator. As you continue to work on your image, you'll add steps to the history. This list can get very long depending on how much you do to your image. If you want to go back to any point in the history, just click on that version and your image will be reset to that point in the process (**Figure 3.22**). A word of warning; you can click on any point in the history line and then back to the latest change only if you don't do any other processing. The moment you perform a new processing step on the older image, all of the old history that took place after the point you went back to will be gone forever. It's kind of like messing with the space-time continuum.

FIGURE 3.22
The History panel remembers every step of your image processing.

VIRTUAL COPIES AND IMAGE STACKS

Virtual Copies is one of those features that really separates Lightroom from all other image editing software. Due to the way Lightroom works, edits to the image are virtual in nature. You can make all the crazy changes to an image in the Develop module that you want, and if you then open that image from the actual folder location in another program, you wouldn't see any of the Lightroom edits. The reason is that the edits are not physically applied to an image until it is exported out of Lightroom. This means that you can create as many virtual copies of your images as you want without worrying that you are filling your hard drive. Virtual Copies lets you apply different processing edits to the same image so that you can create different versions or compare different techniques (**Figure 3.23**). I like to do this when I'm creating a black-and-white version of my image. I might make one virtual copy and do a straight black-and-white conversion on it, and then make another copy and apply a split tone effect, and so on.

The biggest benefit is that I can export any of the virtual copies as an image file with all of the edits and changes, just like I can with my original images.

FIGURE 3.23
Creating virtual copies lets you experiment with different processing settings.

CREATING YOUR COPIES

There are several different ways to create a virtual copy. Go to the Lightroom menu at the top of the screen and choose Photo > Create Virtual Copy. You can also Control-click or right-click on an image and then choose Create Virtual Copy. Perhaps the easiest method is to press Command+' (Ctrl+'). When you activate the command, you should see a message that reads "Virtual Copy 1 Created." You should also see a new copy of your image to the right of the original. You can tell that an image has been cloned because it will have a number in the top-left corner of the thumbnail that shows how many versions exist. In Figure 3.23 you can see that the thumbnail on the left has the number 3 in it because there are two copies. You can tell which images are the copies because of the fold in the lower-left corner of the thumbnail.

STACKING YOUR COPIES (AND ANYTHING ELSE)

When you create a virtual copy, Lightroom automatically creates an image stack of the original and the copies. Image stacks are a way to group a bunch of images into one stack so that you only see the top image of the stack. To collapse the stack, Control-click or right-click on any image in the group, be it the original or a copy, and then choose Stacking > Collapse Stack to hide the other images in the stack (**Figure 3.24**). To expand a stack, choose Stacking > Expand Stack. To quickly expand or collapse a stack, click the set of double vertical lines on the side of the leftmost image in the stack.

If you want a different image to appear on top of the stack, you can Control-click or right-click on it and then choose Stacking > Move to Top of Stack. When your stack is collapsed, this image will be the one you see on top (**Figure 3.25**).

FIGURE 3.25
You can select which image from the stack will be on top when the stack is collapsed.

FIGURE 3.24
You can collapse a stack so that just one image in the stack is visible.

You don't have to limit your stacking to just virtual copies. If you have a group of images that are similar and you don't need to see each one, just make a stack of them by selecting all of the images you want stacked and then Control-click or right-click and choose Stacking > Group into Stack. I use this feature all the time for my bracketed HDR images. There's no need for me to see three or five different exposures of the same subject, so all I have to do is stack them to avoid clutter in my Library. Plus my HDR brackets are much easier to work with.

APPLYING EDITS TO MULTIPLE IMAGES

At times you'll have a group of imported images that will all require the same processing. This is most often the case when you've taken photos of a similar subject under constant conditions using the same camera settings, like a landscape shoot. When that happens, there is no reason to open each image in the Develop module and apply the same edits one after another. Instead, select a large group of images that you want to apply the same processing to and press D to enter the Develop module. Then work on the first image, performing all of the corrections and enhancements necessary to improve the look of the image.

Once the image has been processed to your liking, click the Sync button at the bottom right. This button is normally labeled Previous and allows you to apply the Develop settings from the last processed image to the one that is currently in the preview window. With multiple images selected, the button changes to Sync and allows you to synchronize the Develop settings across all selected images.

When you click the button, the Synchronize Settings dialog appears with options for synchronizing any or all of the Develop settings from the current image. You can elect to have all of the settings synchronized or just a few (**Figure 3.26**). Once you've made your selections, click the Synchronize button to apply the changes to the other selected images.

FIGURE 3.26
Choose which Develop settings you want to apply to the synchronized images.

SYNCHING FROM THE LIBRARY

It's also possible to synchronize your Develop settings from the Library. Just open an image in the Develop module and edit it as you normally would. Then switch back to the Library. Select another image while keeping the just developed image selected. The key is to make the thumbnail that you want to copy from the focused image. When you select other images, they will all appear to have lighter gray thumbnail frames than the unselected images. The focused image will have a slightly brighter frame than the other selected images. You can click once on any selected image to make it the focused image in the group. When you have the desired image set as the focused image, click the Sync Settings button located at the bottom right of the Library panel. The familiar Synchronize Settings dialog appears (**Figure 3.27**). Just as before, choose the settings you want to apply to the selected images, and then click Synchronize.

FIGURE 3.27
You can sync the focused image with other selected photos directly from the Library.

COPY AND PASTE YOUR PROCESSING

If you don't want to apply the Develop settings to a large group but would rather pick and choose which individual images you want to paste the settings to, you can use the Copy feature to record all of the edits applied to the current image. The Copy button is located to the left and under the History panel. Click the Copy button, and a dialog similar to the Synchronize dialog will appear. Just as before, select the Develop settings you want to copy from the current image, and then click the Copy button. When you come across an image that you want to apply those settings to, select it and click the Paste button (it's located next to the Copy button). Lightroom holds your copied settings in memory until you click the Copy button again or close the program.

Chapter 3 Assignments

You just might spend more time in the Develop module than any other module in Lightroom. Therefore, it's important to get to know all of the panels so that you know which one to use in any situation.

Learn the Basics

Of all the panels you will use, the Basic panel is probably the most powerful when it comes to improving the look of your images. Experiment with the Exposure, Highlights, Shadows, and Blacks sliders to see how they complement each other. Also, play around with the Clarity and Vibrance sliders to see how they can punch up a dull image.

Sharp as a Tack

Sharpening is one of those adjustments that people tend to overdo at first. I'm not sure why, but sometimes seeing an ubersharp image gets folks excited. Resist the urge to turn your images into Ginsu knives, and instead try sharpening with control. Apply a modest amount of sharpening with the Amount slider and then use the Option (Alt) key trick to mask the sharpness to just the edges of your subject.

Create a Classic Black and White

Not all images look good in black and white, but when you have a tool that is as quick and easy to use as the Black & White panel, it's fun to try out the technique. Try applying it to images that have some nice contrast. Also, candid people shots can look good as black-and-white images. Reset all of the sliders to 0, and then use the Target Adjustment tool on the image to lighten or darken it as you see fit.

Play with Presets and Create Your Own

The Lightroom team developed some stylish development presets for you to try out. All you need to do is just mouse over them to see how they look. Try making some virtual copies and applying a couple of presets; then compare your images. Then try creating your own preset and see how it looks when applied to different shots. By the way, you can delete a virtual copy at any time by selecting it and pressing the Delete (Backspace) key.

Share your results with the book's Flickr group!

Join the group here: flickr.com/groups/photoshoplightroomfromsnapshotstogreatshots

4

ISO 800
1/1250 sec.
f/7.1
17mm lens

Selective Adjustment

USING THE ADJUSTMENT TOOLS FOR LOCAL EDITS

The previous chapter covered several image-processing tools. Even though they all perform different tasks, they all have one characteristic in common: They are global in nature. By that I mean when you use the Exposure slider, it either darkens or lightens the entire image. When you sharpen, sharpening is applied across the entire image, as are Contrast and Clarity adjustments. Applying adjustments globally is a great place to start, but sometimes localized portions of an image need to be tweaked differently. That's where the adjustment tools come into play. Some of them apply enhancements and some fix problems, but most of them are applied to a specific area, which gives you the power to create some awesome photographs.

PORING OVER THE PICTURE

If you've ever been to Santa Fe, New Mexico, you know that it is a photographer's paradise. If you haven't been, by all means, put it on your list of places to shoot before you die. It is a truly picturesque location with photo opportunities around every corner—like this pair of doors that I found when I walked around a corner. I shot them with a wide angle lens because I wasn't sure how I wanted my final composition to look. This gave me a lot of room to work with the Crop tool when I imported the image into Lightroom.

The Crop tool eliminated all the unwanted areas around the edges.

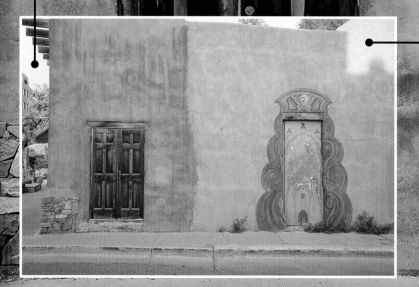

Using the Adjustment Brush, I darkened the one brightly lit area on the wall.

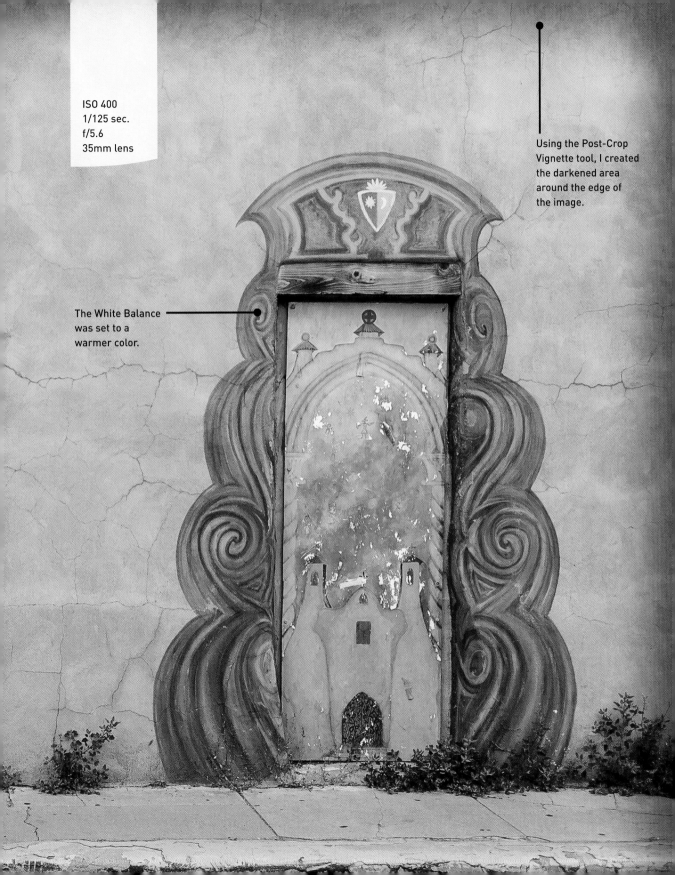

ISO 400
1/125 sec.
f/5.6
35mm lens

Using the Post-Crop
Vignette tool, I created
the darkened area
around the edge of
the image.

The White Balance
was set to a
warmer color.

FIGURE 4.1
Sometimes photos will not import with the correct orientation, and vertical images will appear horizontal.

FIGURE 4.2
Click the curved arrows at the bottom of the thumbnail to rotate your image.

IMAGE ROTATION AND CROPPING

Because I first mentioned tools for global adjustments, I'll kick off this chapter by talking about another global tool that is important for you to know—the Rotate tool. Most cameras today are smart enough to know when you have turned the camera to a vertical position to take a photo, and that information is conveyed to Lightroom. For this reason, most of those images will automatically be rotated to a vertical (sometimes referred to as portrait) orientation. Sometimes there will be a disconnect, and a photo will import in the wrong orientation (**Figure 4.1**).

ROTATING IMAGES

You can quickly correct an orientation problem by choosing Photo > Rotate Left/Rotate Right. I prefer to use the keyboard shortcut Command+[for rotate left or Command+] for rotate right (Ctrl+[or Ctrl+]). It's fast and efficient, and works no matter which view or module you are working in.

If you are into mouse clicking, you can place the cursor over the selected thumbnail and a set of rotation arrows will appear at the bottom of the thumbnail frame (**Figure 4.2**). Just click to rotate the image.

If you have a group of images that need rotating, you can select them all and then apply one of the aforementioned rotation techniques, and Lightroom will rotate them en masse. Just be sure that they all need to rotate in the same direction.

TIP

Rotating more than one image at once works only in Grid view in the Library. You can have more than one image selected in the Filmstrip, but Lightroom will only rotate the image that is being displayed in Loupe view in the Library and Develop modules.

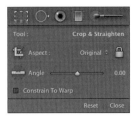

FIGURE 4.3
The Crop tool panel.

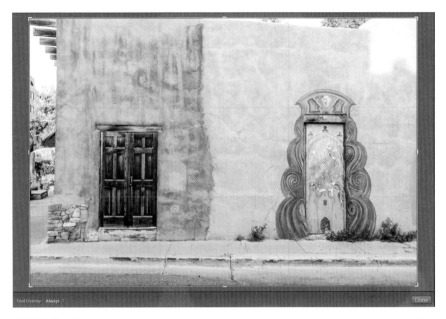

FIGURE 4.4
The Crop tool activates the crop guide and handles on the edges of the frame.

CREATING A NEW COMPOSITION WITH THE CROP TOOL

Maybe it's due to the fact that I learned photography in the darkroom with enlargers and easels, but I really like working with the Crop tool. It lets me discover new compositions for my image that I just didn't see when I took the photo.

You access the Crop tool in the toolbar by clicking on the dotted-line rectangle. You can also hop right into it by pressing the R key. When activated, you'll first see a new set of tools in the Crop panel (**Figure 4.3**). You'll also see that your image is full screen in the preview window and that it has an overlay of lines. If you look closely at the edges of the image, you'll see enlarged corner areas that act as handles for you to grab, move, rotate, and resize the crop guides (**Figure 4.4**). Depending on where you place your cursor, you'll be able to move the crop guide in different ways. If you place your cursor in the corner, it will turn into a double-arrow and will let you drag the crop guide in towards the center of the frame (**Figure 4.5**). If you move your cursor out of the frame and down towards the side, the cursor will turn into a curved double-arrow shape. This indicates that if you click and drag in this spot, the image will rotate inside the crop guide (**Figure 4.6**). This is very handy for straightening your photos, especially if you shoot a little crooked like me.

FIGURE 4.5
Placing your cursor at the corner lets you resize two sides of the image at once.

FIGURE 4.6
Move the cursor down from the corner, and you'll see the rotation cursor.

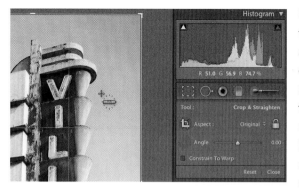

FIGURE 4.7
The Straighten tool looks like a ruler and will straighten photos when dragged along a vertical or horizontal line in the image.

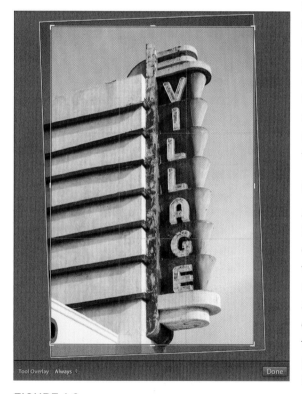

FIGURE 4.8
The edge of the building was used to straighten the vertical lines.

Using the Crop tool can take a little getting used to, especially if you've cropped images using another editing program. The reason is that the crop guide floats above the image and doesn't move. When you crop, the image moves behind the guide. So when you want to reposition the new crop over the image, you place your cursor in the middle of the frame and grab the photo to move it around, not the crop guide. Once you get used to it, you'll love the way the Crop tool works.

If dragging lines isn't your style and you are more accustomed to dragging out your own crop guides, you can use the Crop Frame tool. It's the tool in the Crop panel that looks like two right angles on top of each other. To use it, just click the tool and then drag out the crop that you want on top of your image. Be sure to draw your crop towards the opposite corner. When you release the tool, you'll be able to reposition the crop guides by dragging or rotating. If at any time you want to remove the crop and start over, just click the Reset button at the bottom of the Crop panel.

STRAIGHTENING AN IMAGE

As mentioned earlier, you can fix a crooked photo by rotating the crop window, but there are a couple of other ways to do this as well. If you have vertical or horizontal lines in your image, you can use the Straighten tool to drag a straight line along something you want to look perfectly vertical or horizontal. The Straighten tool is the icon that looks like a ruler inside a circle in the Crop panel. Just click and drag along a line that should be at 90 degrees (**Figure 4.7**). When you release the mouse button, the photo will automatically rotate to the correct angle and straighten out the image (**Figure 4.8**).

The other method of straightening your image is to use the Angle slider in the Crop panel. Just grab the center positioning triangle on the slider and move it left or right until your image looks straight. Be sure to take a good look at the image as it is rotating. Lightroom overlays a small grid on the image as it is rotating to give you a little guidance.

CHANGING YOUR ASPECT RATIO

In the Crop panel you may have noticed a small padlock with the word Original to the left of it. The lock means that your aspect ratio, or the ratio of length versus width, is locked and will remain constant no matter how small you crop or rotate your image. If you want to change the actual dimensions of the image—that is, make the length or width longer than the original—you need to unlock the padlock by clicking it. Once you have unlocked it, you can move the crop guides independently of each other.

FLIPPING THE RATIO

Whenever you are drawing out a locked crop guide, you will probably find that it is stuck to the orientation of your image. That is, it will keep the long side long and the short side short. But what if you wanted to make a vertical crop selection inside of a horizontal image (or vice versa)? The solution is just a keystroke away. To flip the crop from one orientation to another, just press the X key (**Figure 4.9**).

FIGURE 4.9
Pressing the X key lets you flip the cropping aspect ratio.

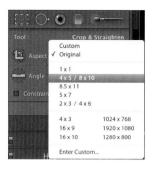

FIGURE 4.10
A number of preset crop ratios are available to choose from, or you can create your own.

In addition, some popular preset sizes are available that might already suit your needs, such as 8x10, 1x1, 5x7, and so on. You can find these by clicking the arrows between the word Original and the padlock. When the menu opens, select the size you want, and then crop your photo as you normally would (**Figure 4.10**). You can also enter a custom crop size that you can add to the list to use whenever needed.

SPOT REMOVER

Shooting with a DSLR camera is great because it offers so much flexibility in lens selection. The problem is that changing lenses creates opportunities for dust to enter your camera body where it usually ends up finding a home on your image sensor. You can't see it when you are shooting, but when you zoom in on your photo, there it is, clear as day. That's when the Spot Removal tool comes in handy. The easiest way to use the tool is to either click the icon in the toolbar (it's the circle with the arrow coming out the side) or press the Q key. When activated, a control panel drops down under the toolbar that lets you change the size of your brush and the opacity. You can also change the mode of the brush from Heal, which removes spots, to Clone, which allows you to copy an area in your image. I almost always use the Spot Removal tool in Heal mode, which samples a piece of the image from an adjacent area (source) and allows you to repair the problem area wherever you click (destination). It does a great job of matching the source to the destination, but if it's not quite right, you can move the source spot and sample a new location.

FIGURE 4.11
Make your brush size just a little larger than the spot you want to remove.

USING THE SPOT REMOVAL TOOL

Follow these steps to repair an area of your image with a sample from another area.

1. With the brush set to Heal, enlarge your image in the preview window by pressing Z.

2. Hold down the spacebar and drag your photo around in the preview window until you find the dust spot that you want to remove.

3. Release the spacebar, and then place your cursor over the dust spot.

4. Resize the brush using the Size slider until the cursor is just slightly larger than the spot (**Figure 4.11**).

5. Click to remove the spot, and if necessary, move the source circle to a better spot to sample.

> **TIP**
>
> If you want an easier, faster method of resizing your brush, press the left and right bracket keys ([and]). The left bracket makes the brush smaller; the right makes it bigger.

GET THE RED OUT

If you use an on-camera flash to take people pictures, you're bound to get some red eye shots eventually. If that happens, click the Red Eye Correction tool on the toolbar. This is one of the easiest tools to use, and it does a fantastic job of eliminating red eye.

USING THE RED EYE TOOL

Follow these steps to remove red eye from your images.

1. Click the Red Eye Correction tool in the toolbar (the icon looks like an eye).

2. Hold down the spacebar and drag your photo around in the preview window until you find the eye(s) that you want to correct.

3. Release the spacebar, and then place your cursor crosshairs directly in the center of the pupil. Click and drag out a circular selection around the pupil (**Figure 4.12**).

4. In the Red Eye Correction panel adjust the pupil size and darkness (**Figure 4.13**).

5. If you are correcting more than one eye, move the cursor over the next eye and either click in the center or drag out a new circle as you did before.

6. Repeat step 4, and then click Done at the bottom of the preview window.

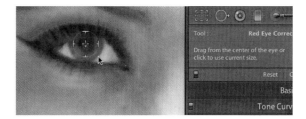

FIGURE 4.12
Click in the center of the pupil, and drag out a circle around the pupil.

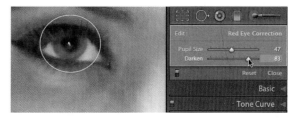

FIGURE 4.13
Adjust the sliders in the panel to fine-tune the correction.

GRADUATED FILTER

In traditional photography, if you wanted to darken a sky without darkening the foreground, you would have used a graduated neutral density filter on the front of your camera lens. The filter was usually two or three stops darker at the top and would then lighten back to clear towards the center. You can still use graduated glass filters in your photography, but you also have the option of adding the effect in Lightroom with the Graduated Filter feature. What's even better is that the Graduated Filter in Lightroom isn't just limited to going from dark to light. You can also use it to lighten an area of an image or change the color temperature of the filtered area (this feature is only available in Lightroom 4). In fact, just about any other adjustments that you might make using the other Develop panels can be applied in a graduated fashion using this tool.

Click the Graduated Filter icon in the toolbar to see a large panel of options beneath the toolbar (**Figure 4.14**). You can add all of these adjustment sliders to the filter to create just the effect you want.

So, in **Figure 4.15**, for example, the foreground looks good but the sky needs a little darkening and perhaps an increase in saturation. It would also be nice to add a bit of contrast to the clouds.

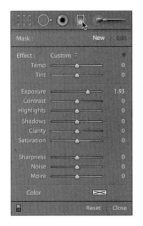

FIGURE 4.14
The Graduated Filter and adjustment slider panel.

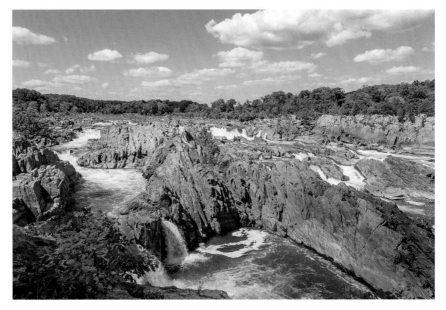

FIGURE 4.15
The sky in this image needs some darkening and a little color enhancement.

APPLYING THE GRADUATED FILTER

To make adjustments to selected areas of an image, the sky in this example, follow these steps.

1. To darken the sky, set the Exposure slider to a darker setting. I prefer to go a little overboard by moving the slider to about –2 stops so I can see where my filter is being applied and then lighten it later.

2. Place your cursor above the image in the preview window and drag down towards the bottom, releasing when you think the filter is applied to the right area (**Figure 4.16**).

3. If you darkened the effect too much with the Exposure slider, you can now adjust the slider to a setting that is right for the look you're after.

4. Add some Clarity and Contrast to fix the clouds.

5. Add a little Saturation to help intensify the color of the sky.

When complete, you'll end up with a more dramatic-looking photograph (**Figure 4.17**). The great thing about the Graduated filter is that you can go back at any point in time and readjust the settings. You can also apply additional graduated filters by clicking the word New at the top of the slider panel.

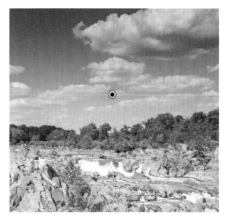

FIGURE 4.16
Start by clicking at the top, and then drag the Graduated Filter towards the bottom of the image.

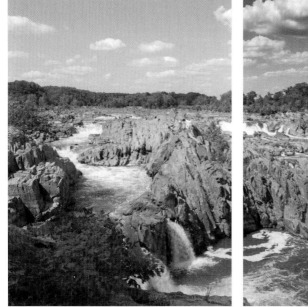

Before

After

FIGURE 4.17
Here are before and after shots that show the dramatic effect a graduated filter can have.

WORKING WITH MULTIPLE ADJUSTMENTS

If you add more than one adjustment using any of the adjustment tools, you can always return to the previous adjustments and edit them. Every time you create a new adjustment, Lightroom applies a circular edit pin to show the location of the adjustment. The active adjustment pin will display a black inner circle; others will be solid white (**Figure 4.18**). To make changes to a different adjustment, just click the pin to make it active. If you want to hide the pins, press O or change the Show Edit Pins option at the bottom of the preview window.

FIGURE 4.18
Every time you add a new graduated filter or adjustment brush, a new adjustment pin is applied.

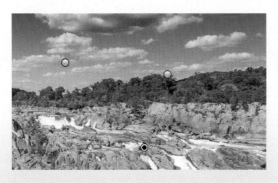

SELECTIVE FIXES WITH THE ADJUSTMENT BRUSH

Sometimes there will be variables in your photographs that you have no control over, and all you can do is capture the best exposure possible. This dilemma is a little less daunting when you know you can fix problem areas in your image using the Adjustment Brush. What is the Adjustment Brush? It's essentially like having the features in the Basic and Detail panels on a brush that you can selectively apply to your image (**Figure 4.19**). With the release of Lightroom 4, a few new brushes were added, but for the most part, they are the same as those available in version 3.

The general concept when using a brush is that you adjust the sliders to render the desired result—like darkening a particular area and perhaps applying some warmth to it—and then brush those adjustments onto the photograph. You can increase or decrease the size of the brush using the Size slider in the panel or by using the left and right bracket keys. You'll also notice a larger, dotted circle around the brush. This is the Feather for the brush, and it determines how smoothly the effect ends. So, if you want a very hard edge, you should use a very small Feather of 10 or less. As you move past 10 towards 100, the edges of the brush will get very soft, which can create a nice transition from the adjusted to the nonadjusted areas (**Figure 4.20**).

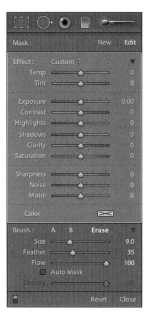

FIGURE 4.19
The Adjustment Brush panel.

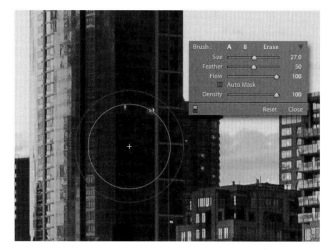

FIGURE 4.20
Use the Brush sliders to create the shape and behavior of your Adjustment Brush.

If you happen to make a mistake and brush over an area where you didn't want the adjustment, you can use the Erase brush to remove the change. The Erase brush works just like the Adjustment Brush in that it can be sized and feathered to your needs. You can access the Erase brush by clicking the word Erase in the bottom portion of the Adjustment panel, but I prefer to use the Option (Alt) keyboard shortcut. This shortcut does not turn on the Erase brush; it just makes it active for as long as you hold down the key. When you are done erasing, just release the Option (Alt) key and you are instantly back in the Adjustment Brush. If you choose to use the Erase brush by clicking it instead of using the keyboard shortcut and get confused as to which brush you are using, just look for the symbol in the middle of the brush. A plus (+) symbol means you are using the Adjustment Brush. A minus (−) symbol means you are using the Erase brush.

As you paint on your image, you will be creating a mask that only shows the effect in those areas you have brushed over. If you want to see exactly where that is, hover your mouse over the edit pin that shows where you started painting (these are the same edit pins created in the Graduated Filter tool). As you hover over it, a red over-lay appears on all affected areas where you have painted (**Figure 4.21**). If you want to leave the mask on, you can select the Show Selected Mask Overlay check box at the bottom of the preview window. This can be helpful when you are painting over a large area and want to make sure you haven't missed any spots.

FIGURE 4.21
You can hover your
mouse over an
adjustment pin to
see the mask you
have created.

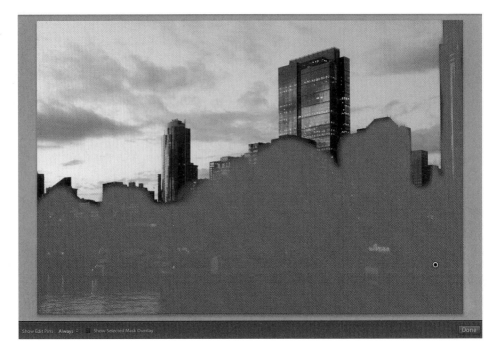

AUTO MASK FOR GOOD-LOOKING EDGES

You can use several controls to get accurate adjustment masks, like fine-tuning the brush Size and Feather controls, but sometimes it is extremely difficult to get a clean line between subjects. That's where the Auto Mask comes into play. The Auto Mask confines the brush to areas of similar color, so even if the edge of your brush wanders into another colored area, the brush will only paint on areas that are the same color as that which is directly under the center of the brush. All you need to do is select the Auto Mask check box in the Adjustment panel and then start painting around the edges (**Figure 4.22**). It's best to paint any large areas with the Auto Mask turned off and only turn it on near edges.

When working with the Adjustment Brushes, it's important to remember that you can apply multiple adjustments to the same brush. So if you want to add Clarity and Sharpening, all you have to do is move the sliders for those adjustments and brush them on. You can always come back after the fact and readjust until you get just the look you're after. And just like the Graduated Filter, you can apply multiple brush adjustments to your image. Just click the word New at the top of the panel to create a new brush. Just remember to set up the adjustment sliders for this new brush, because it will default to the last settings used.

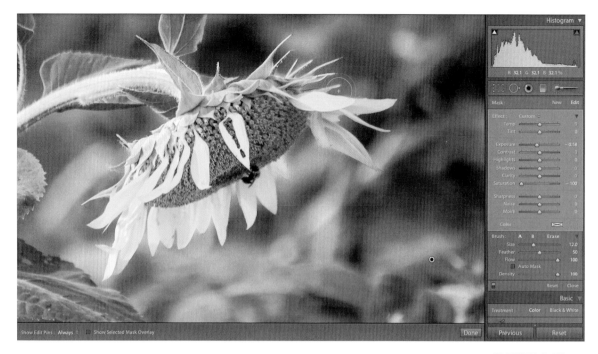

FIGURE 4.22
The Auto Mask restricts the brush to painting on just one color.

With practice and some experimentation, you'll not only correct your images using the Adjustment Brush, but you'll have the power to transform them into unique and compelling images (**Figure 4.23**).

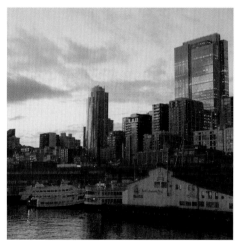

Before

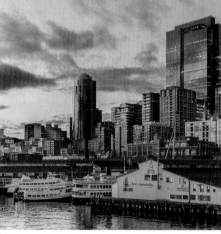

After

FIGURE 4.23
You can create very dramatic changes to your image by using the Adjustment Brush tool.

USING ADJUSTMENT PRESETS

If you aren't quite sure where to start with your Adjustment Brush edits, you can click the word Custom at the top of the panel to open the Presets Option menu (**Figure 4.24**). These presets give you a good starting point for whatever it is that you want to do with your image. There are even some specialized presets at the bottom that I'll talk more about in the next chapter. If you create a brush that you think might be handy in future editing sessions, you can open the Preset Options menu and click Save Current Settings as New Preset to bring up a naming dialog. Give your new preset a meaningful name, and then click Create to add it to the Presets list (**Figure 4.25**).

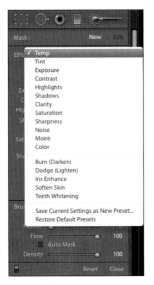

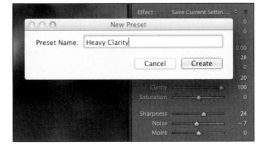

FIGURE 4.25
Creating your own preset is as easy as adjusting the sliders and then saving and naming it.

FIGURE 4.24
Several Adjustment Brush presets are available to get you started, or you can create your own.

Chapter 4 Assignments

The great thing about Lightroom is that you can use the tools to do just about anything to your image and always be able to get back to where you started without ever damaging your original. So let's start playing.

Find the Photo Within the Photo

Cropping can completely transform the composition of your image or just help you remove clutter from the edges. Play with the Crop tool and learn how to resize and move your image within the crop guide. Try some new presets and maybe create one of your won. Also, flip the aspect ratio by pressing the X key and see if you can find a whole new perspective on your shot.

Try Some Spot Remover

If you have dust spots in your photos, try eliminating them with the Spot Removal tool. The nice thing about this tool is that you can also use it for removing blemishes in portraits. Open a photo with spots, press Q to jump to the Spot Removal tool, and start making those spots disappear. For spots in light areas, like the sky, you might want to try cranking the Blacks slider in the Basic panel to –100 to really make those spots visible. When you are done removing them, just set your Blacks slider back to normal.

Add a Graduated Filter, or Two

The Graduated Filter is one of my go-to tools when I'm working with landscape photos. I'll discuss some other techniques for enhancing skies in the next chapter, but for now try clicking the Graduated Filter tool and dragging one out on your photo to darken the sky. Don't forget to lower the Exposure setting a couple of stops first to really see where the filter is being applied. Then go back and adjust the setting until it looks just right. Also, try adding some other effects to the graduated effect you just created. Go ahead and get a little crazy. You can always reset the settings when you are done.

Let's Go Local

Go local with your edits, that is. Start with a simple adjustment, like lightening an area by setting a high Exposure or Shadow setting. Hold down the Option (Alt) key and erase a little of what you just did. Next, click on the Auto Mask and see how it works when painting around edges of differing colors. Don't be afraid to adjust the other sliders and really crank up the settings to get a good visual of how they affect your image. Click the New button and create a whole new adjustment. When you're done, click the pins and then press the Delete (Backspace) key to remove them one at a time or click Reset at the bottom of the panel.

Share your results with the book's Flickr group!

Join the group here: flickr.com/groups/photoshoplightroomfromsnapshotstogreatshots

5

ISO 400
1/1600 sec.
f/11
18mm lens

Fine-tuning and Special Effects

TAKING YOUR IMAGES TO THEIR FULL POTENTIAL

Recently, I wrote a short article on some of the develop tools available in Lightroom. Someone commented on the article stating, "I love Lightroom because it makes me a better photographer." I can see how someone might say that, but the reality is that Lightroom won't make you a better photographer. However, it will help you to unleash the potential that lies in your photographs. Using Lightroom provides you with a method of realizing your vision through the application of image processing. Your photograph is a rough-cut stone, and Lightroom helps you polish it into a gem.

This image was taken during an 8-hour bus journey across the Alto Plano of Peru. I really liked the solitude of the small house on the plains with the foothills of the Andes rising behind it. Unfortunately, the colors didn't look as good as they probably would have had I not been shooting through tinted glass. Also, the skies had great clouds, but they ended up being a little washed out in my photo. The easy answer for these problems was simple; make it a black-and-white photo.

Adding a split tone gave the final image some warmth.

Setting the Blue slider to –64 in the B&W panel darkened the skies.

ISO 400
1/1600 sec.
f/6.3
135mm lens

Adding lots of Clarity helped raise the contrast of the midtones.

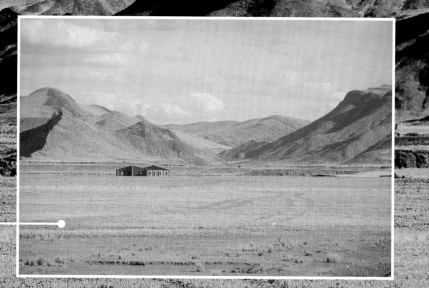

Cropping the photo eliminated some of the empty space in the foreground.

CREATING BETTER SKIES

Because I already touched on sky processing in the previous chapter, I thought I'd kick off this chapter with some additional tricks to really make the skies in your photos pop.

The problem with skies is that they are usually much brighter than the rest of the subjects in the scene. Even though it may not look like it to your naked eye while shooting the photo, brighter skies will usually appear in your photos.

DROPPING THE HIGHLIGHTS

The first step to improving the sky in an image is to process your image as you normally would. This means making everything else in the image look good by adjusting Exposure, White Balance, Clarity, and so on. Once that is done, view the histogram and determine whether clipping is occurring in the sky, especially if there are clouds. One of the best ways to improve your image is to start moving the Highlights slider to the left. If you are using an older version of Lightroom, you would use the Recovery slider. Press the J key to turn on your clipping warning, and then start dragging the slider until you bring back details in the clouds and remove all clipping. If you really want a lot of detail in the clouds, move the Highlights slider to −100 (+100 with the Recovery slider) (**Figure 5.1**).

FIGURE 5.1
Use the Highlights slider to eliminate clipping in your highlights.

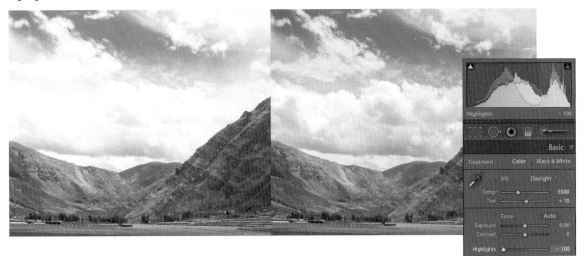

NOTHING BUT BLUE SKIES

Now that you have some nice-looking clouds, let's improve the color of the sky. This is often necessary because the camera can have a tough time capturing the color of the sky due to the atmospherics. This has to do with the relative angle of the sun and some other factors that are usually out of your control. But here's a little tip that has been helping landscape photographers for some time—use the HSL adjustment panel. To improve the blue sky, click the HSL panel in the Develop module and then click Luminance. You can make a color change in one of two ways: Drag the blue slider to the left, or use the Target Adjustment tool and click and drag down on a section of blue sky. The key is not to darken the sky too much to the point where you make the photo look artificial.

Then click Saturation at the top of the panel and move the Blue slider to the right or drag up with the Target Adjustment tool. The Target Adjustment tool might actually be the better tool to use at this point because the color in the sky might contain a mix of colors, like blue and aqua. You may need to go back and adjust the Luminance after adjusting the Saturation because the image could become darker. Just find the combination of adjustments that works best for your image (**Figure 5.2**).

Before

After

FIGURE 5.2
Lowering the Lumi-nanace and raising the Saturation of the blues in the HSL panel can have a dramatic effect.

USING THE GRADUATED FILTER

Even though I discussed the Graduated Filter in Chapter 4, it's beneficial to cover it once more as it relates to skies. The key to using this effect on your skies is to have a flat horizon line. If you tried this filter on an image like Figure 5.1, you would darken the sky but also the tops of the hills, which is not where you want the darkening to occur.

1. Click the Graduated Filter icon in the toolbar.

2. Make sure all sliders are set to 0, and then set the Exposure to –2.00. This will make your image very dark where the filter is applied, but it will help you determine how far to drag down the filter.

3. Hold down the Shift key while you click and drag down from the top of the image until you have the adjustment to the point where it is darkening the sky but not affecting the ground.

4. Using the Exposure slider, lighten the effect.

5. Try adding Highlights if any clouds were darkened.

6. Move the Saturation slider to the right to add some color vibrance.

Every image will be different and will need to be adjusted as needed. Just play with the settings until you have the look you want (**Figure 5.3**).

FIGURE 5.3
The Graduated Filter can help darken the top portion of the sky.

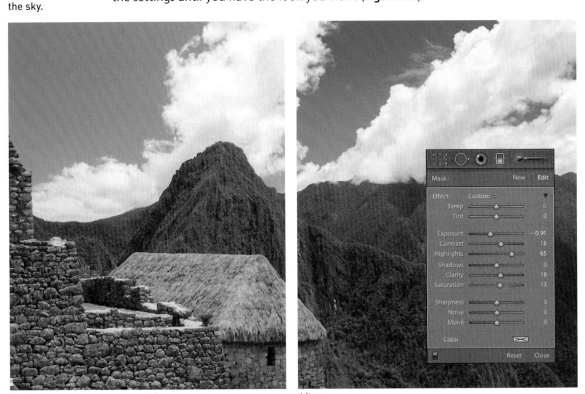

Before After

CREATING A CLASSIC BLACK-AND-WHITE IMAGE

Recall in Chapter 3 that I quickly covered the B&W panel for making adjustments. Let's dig a bit deeper into the technique to see how you can transform your photos into classic works of art. When converting an image, I usually create a virtual copy first. If you want to compare a few different looks, just make more virtual copies. Remember that the new copies are virtual so they don't take up space on your hard drive; instead, they just let you try different effects without having to reset your image.

ADJUSTING THE TONES WITH THE B&W PANEL

When you've made a virtual copy of your image, press V to quickly turn it into a black and white. The result is Lightroom's idea of what your image should look like, so you need to take control of the image's appearance by opening the HSL/Color/B&W panel and then clicking the Target Adjustment tool.

With the Target Adjustment tool active, start clicking and dragging on different areas in your photo to lighten or darken them based on their color (which of course you can't see anymore). One of the great features of this tool is that as you move your mouse across your image, whatever the underlying color is will be highlighted in the slider panel. So if you have the tool over a section of sky, the Blue slider will be highlighted. As you click and move up to lighten and move down to darken, the slider will adjust in the corresponding direction (**Figure 5.4**).

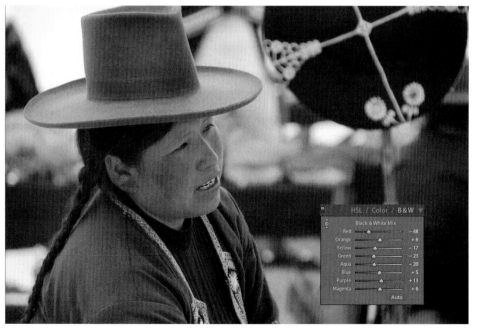

FIGURE 5.4
Use the color sliders in the B&W panel to adjust the tonal values in your photo.

BACK TO THE BASICS

Once you have the black-and-white tonal values the way you want them, click the Basic panel to fine-tune the exposure and contrast. The sliders you want to use in the Basic panel are those in the Tone and Presence sections. Start by adjusting Exposure if necessary, and then adjust the Highlights. Controlling the highlights is important because when you add contrast, it can cause bright highlights to clip even more. The Whites and Shadows sliders will work just as they always do and should be adjusted accordingly. Depending on how gray the overall image is, you might want to raise the Whites slider and lower the Blacks slider to add some contrast while leaving the midtones intact.

Because the image is black and white, you won't be able to make any adjustments to the Vibrance or Saturation sliders. But you can add some Clarity to your image. Adding a lot of Clarity will give your photo that extra bit of snap or punch that most people want in their black-and-white images (**Figure 5.5**).

FIGURE 5.5
Adding Clarity in the Basic panel can add some visual pop to your black-and-white photos.

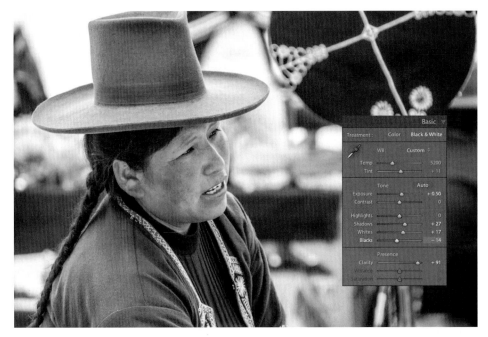

TWEAKING THE CURVE

It's my usual practice to adjust the contrast by using the Tone Curve panel. At the bottom of the panel, click the word Linear and change it to Medium Contrast. This is usually a pretty good starting point. Then adjust the Lights and Darks sliders to fine-tune the contrast in the image (**Figure 5.6**).

GETTING THAT FILM LOOK

Even though you strive for a clean-looking color photo, that's not always the case when creating a black and white. Black-and-white images were traditionally created using black-and-white film. The film was made of light sensitive granules that, when processed, were referred to as grain. Digital cameras don't have grain, but you can add some using the Effects panel to simulate the look of a traditional black-and-white film image. For a classic Kodak Tri-X look, use a setting of Amount 45, Size 25, and Roughness 50 (**Figure 5.7**). Then adjust the settings to your liking.

FIGURE 5.6
Finish the black-and-white adjustments by adding contrast and adjusting the Lights and Darks sliders.

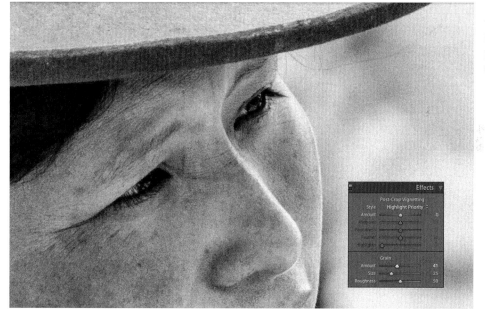

FIGURE 5.7
You can give your black-and-white photo a film look by adding some grain.

START WITH A PRESET

Adobe has included some appealing presets in the Develop module, and a majority of them are for converting an image to black and white. The first group in the Presets panel is called Lightroom B&W Filter presets, and they include options to simulate the effect of photographing in black and white using colored filters. The second group is simply a grouping of different black-and-white looks. Some of the presets are high contrast, some are flatter, and some have vignetting. To see how they would look on your image, just place your cursor over the preset name and view the result in the Navigator panel.

The final group of presets is referred to as toned presets and is reminiscent of traditional black-and-white toning processes like Sepia, Cyanotype, and Selenium. Fortunately, you get to skip dealing with all the caustic chemicals by clicking these presets to apply one of these looks to your photo (**Figure 5.8**).

FIGURE 5.8
You can achieve different looks by using the built-in black-and-white presets.

These presets offer several different effects for your photos, but more important, they can help you jump-start enhancements to your images when you aren't sure what to do. Because these presets are adjustments, you can always go to the Develop panels and change the sliders until your image looks just the way you want.

A BETTER-LOOKING DUOTONE

One visual effect that is very popular is duotoning, or as Lightroom calls it, Split Toning. This effect adds a color wash to the highlights and shadows in your image (see Chapter 3). Most people will select a color and saturation point for the highlights and then use the same or a similar setting for the shadows. Here's the real secret to a good-looking duotone: Only add color to the shadows. This will give a nice overall color tone to the image while keeping the effect subtle. A good starting point for a classic duotone is to set the Shadows to a Hue of 50 and a Saturation of 20 (**Figure 5.9**).

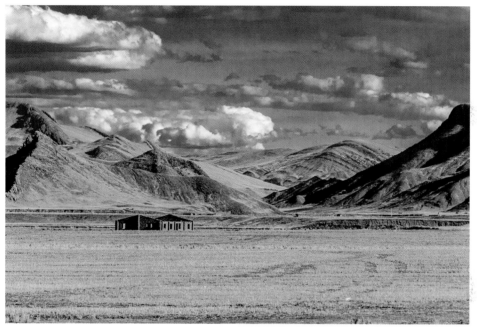

FIGURE 5.9
You can create a great-looking duotone by using the Split Toning panel.

DODGING AND BURNING

One way to help guide the viewer's eyes around your image is to use a technique called *dodging and burning*. These terms originated from the traditional black-and-white darkroom. When photographers dodged a paddle between the enlarger light and the photo paper, it would hold back light from the image, making it lighter in the dodged areas. To make certain areas darker, they would allow more light to hit the paper in the desired area, thereby burning in the image. Fortunately, this is a much easier process in Lightroom.

Dodging and burning is accomplished with the Adjustment Brush. The idea in the dodging and burning process is that the human eye looks at light areas before dark areas, so you should darken, or burn in, the areas of least importance. You can also lighten areas to help draw the eye to them. In **Figure 5.10** the woman is the main subject but is too dark because her hat is shading her, so I'll lighten her a little. I'll set the Exposure slider on the Adjustment Brush to +.42 and use a soft brush to lighten the desired areas (**Figure 5.11**). Next, I'll create a new adjustment by clicking New, setting the Exposure slider to −.50, and then painting areas that I want slightly darker, like the land in the background and the boat (**Figure 5.12**). The key to dodging and burning is to try to keep the adjustments subtle (**Figure 5.13**). Also, use as many brushes as you need to. Not all areas will require the same amount of dodging and burning, so don't be afraid to treat them separately with a new adjustment. Remember that you can click any of the adjustment pins and change the amount of adjustment using the Exposure slider.

FIGURE 5.10
This image needs some dodging and burning to help focus attention on the woman rowing the boat.

FIGURE 5.11
Set the Exposure slider to a higher setting and apply the adjustment to areas that need lightening.

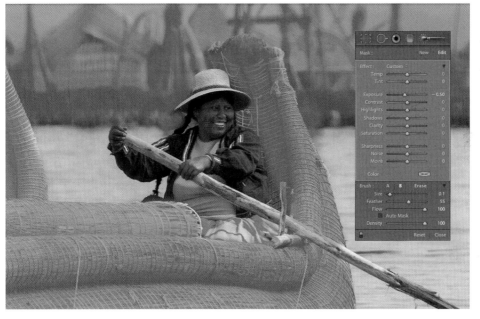

FIGURE 5.12
Create a new adjustment and paint a darker exposure to burn in background areas.

FIGURE 5.13
The dodging and
burning has refo-
cused attention to
the main subject.

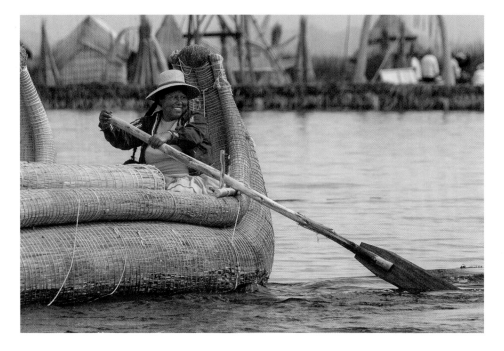

ADDING VIGNETTES

Another technique that has become very popular recently is to add a vignette around the outside of your image. This forces the viewer's eyes towards the interior of the image and away from the outside edges.

The simple way of adding a vignette is to:

1. Click the Effects panel and then move the Amount slider of the Post-Crop Vignetting tool to the left (somewhere between –15 and –30) to darken the corners of the frame.

2. Adjust the Midpoint slider to set how far into the image the vignette will appear.

3. Move the Roundness slider to the right to make the vignette rounder or to the left to square up the sides.

4. Adding a Feather of 50 is usually adequate, but you can set a higher number for a more feathered look or a lower number for a harder edge.

5. Move the Highlights slider to protect some of the lighter areas around the edge of the frame.

You can also create frame effects using the Post-Crop Vignetting tool. Try the following settings for some different looks.

FIGURE 5.14
Use these settings to get a grungy-looking border.

FIGURE 5.15
These settings will create a film-like border.

For a grungy edge look (**Figure 5.14**):

- Style: Highlight Priority
- Amount: -65
- Midpoint: 33
- Roundness: -80
- Feather: 44
- Highlights: 0

For a black film-type frame (**Figure 5.15**):

- Style: Highlight Priority
- Amount: -100 (use +100 for a white frame)
- Midpoint: 0
- Roundness: -100
- Feather: 0
- Highlights: 0

FIGURE 5.16
You can create some high-key vignettes by moving the Amount slider to a positive number.

For a high-key white vignette (**Figure 5.16**):

- Style: Highlight Priority
- Amount: +50
- Midpoint: 50
- Roundness: 0
- Feather: 50
- Highlights: 0

These are just a few samples of what you can do with the Post-Crop Vignetting tool. Experiment with the styles and sliders, and then create a Develop preset so that you can quickly apply it to other images in the future.

SMOOTHING SKIN

Normally, when I think of the Clarity adjustment, I think of adding contrast. I use it all the time to punch up a flat-looking photo that needs some added midtone contrast. But there is an opposite setting that has a fantastic effect on skin. If you set the Clarity slider on the Adjustment Brush to a negative setting, it actually reduces midtone contrast. This is great for smoothing out skin because that's what people see when looking at skin texture. Differences in the contrast of the skin surface, the pores, and tiny lines create texture. So, by reducing this contrast, you can create the appearance of smoother skin.

To use a preset for smoother skin, head to the Adjustment Brush presets and select the Soften Skin preset. If you want to set the sliders on your own, set the Clarity slider to -100, the Sharpness to +25, and the Density to 75.

FIGURE 5.17
Apply negative Clarity with the Adjustment Brush to soften skin.

Then just use a soft-feathered brush and paint the effect onto the skin. Try to avoid areas that should not be softened, like lips, eyes, eyebrows, and so on. If you find that the effect is too much, just back off the Clarity slider until you get just the look you want (**Figure 5.17**).

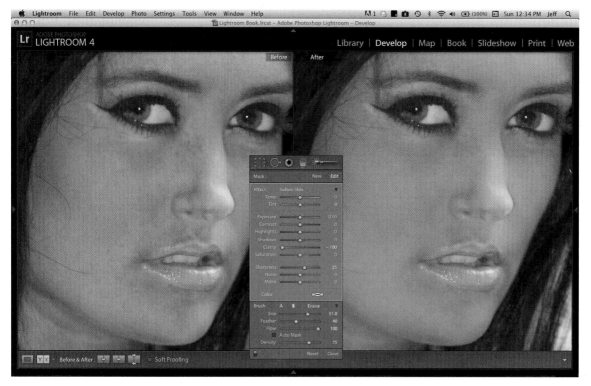

CREATING A FAUX HDR EFFECT

Quite often, I like to apply a faux HDR effect to my photos. There is just something appealing to me about a photo that has crisp, sharp details and expanded tones. To create a real HDR photo, you need to use an external editing program, like Photoshop CS5, Nik HDR Efex Pro, or Photomatix Pro. These programs have features that can combine multiple exposures of the same scene to get maximum detail and information from the shadows, midtones, and highlights. Because you are just using a single image in Lightroom, you really can't do what those other programs can. But you can cheat a little to get the same "look" that an HDR program can create.

A TALE OF TWO METHODS

When Adobe released Lightroom 4, several changes were made to the sliders in the Tonal section. The changes made were convenient and helpful, but they did change the way this HDR technique is applied. Therefore, I'll show you two differ-ent methods. One uses the 2012 Camera Calibration process, and the other uses the Lightroom 3 process (2010). Of course, if you are using Lightroom 3, the latter will be your only option, but that's OK because it is the better of the two.

To create the faux HDR look using the Lightroom 4 sliders, go to the Basic panel in the Develop module and apply the settings in **Figure 5.18**. To finish the tech-nique, add some sharpening and a vignette (**Figure 5.19**).

FIGURE 5.18
Try these settings to get a faux HDR look.

FIGURE 5.19
Here's a before and after using the Lightroom 4 HDR settings.

Before

After

FIGURE 5.20
The Develop settings can be changed to behave as they did in Lightroom 3.

FIGURE 5.21
Use these settings for a more over-the-top HDR look.

For the second method, Lightroom 3 users will have one fewer step and that is to go to the Camera Calibration panel in the Develop module. Lightroom 4 users need to open the panel, click 2012 (Current) in the Process section, and change it to 2010 (**Figure 5.20**). This will change the names and behaviors of some of the sliders in the Basic panel.

Next, click the Basic panel and apply the settings in **Figure 5.21**. As with the previous setup, you should add sharpening and a vignette, and tweak the settings to fit your image (**Figure 5.22**).

FIGURE 5.22
Here's the before and after using the Lightroom 3 HDR settings.

Before After

Chapter 5 Assignments

Sometimes you just want to import your photos and make them look nice. But then there are times when you really want to add some pizzazz. Most likely, you would think of turning to a different program, like Photoshop or Elements. However, Lightroom has some pretty great tools available that can really transform your photos. Be sure to explore those tools by completing these assignments.

Creating Better Skies

I don't try to enhance the skies in every photo, but I do for those that matter. Create a virtual copy of your sky image, and then head to the HSL panel to start playing with the Luminance and Saturation sliders. Don't stop there, though. Try using the Graduated Filter to make one of those picture postcard-type skies. Remember that you can hold down the Shift key to keep the filter straight while dragging it out.

Go Black and White

Are you a fan of Ansel Adams or Edward Weston? Well, you are only a few clicks away from creating your own classic black-and-white masterpiece. Press the V key to quickly turn your image into a black and white. Then use the features in the B&W panel. Start playing with the color filters to add custom tweaks to the image. Don't forget to finish the image by making some adjustments in the Basic panel.

Fix a Portrait

It's your job as photographers to try to make your subjects look as good as possible. One way to do that is to make small edits that eliminate little details that you don't see in person but that seem to stand out when you take a photo. Start by using the Spot Removal tool to fix small blemishes. Then use the Soften Skin Adjustment Brush preset to smooth out the skin. Finally, if the subject's teeth aren't as bright and white as they could be, hit them with the Teeth Whitening preset. As a little bonus, try using the Iris Enhance preset to brighten the subject's eyes.

Make a Fake HDR (you know you want to)

Not every image looks good with an HDR effect added to it, but it can be very cool when it's used on the right shot. I like to use it for architecture and subjects that are already kind of grungy. Try using the settings specified earlier and then tweak them for your image. If you like the look, try saving it as your own HDR preset, and then see how it looks on some of your other shots.

Share your results with the book's Flickr group!

Join the group here: flickr.com/groups/photoshoplightroomfromsnapshotstogreatshots

6

Off to the Presses

HOW TO CREATE YOUR OWN PHOTO BOOK

Up to this point in the book you have been working on the basics of the photographic workflow. You have imported and organized and then processed and enhanced. Now it's time to do something with all those great-looking photos. If you are working with a version of Lightroom earlier than version 4, I'm sorry to say that you won't get much from this chapter (except maybe an urge to upgrade). The reason is that Adobe added a great feature to Lightroom 4—the ability to create custom photo books that can be electronically transmitted to Blurb for printing or just converted to a PDF file for sharing. Either way, it's a feature that is well worth the price of the upgrade.

PORING OVER THE PICTURE

Death Valley is one of those places that I had always heard of but never really thought of as a must-visit location. That is until last year when I had a free day in Nevada and decided to make the drive. I had no idea that the scenery would be as magnificent and varied as it is, and I'm just glad that I had my camera with me. After spending a day driving through the park, I couldn't wait to relive the experience and share it with friends through my photos.

Using the Tone Curve panel, the overall contrast of the image was increased.

Adding some saturation in the blues enhanced the skies.

The raw file was a little soft, so I added quite a bit of sharpening in the Details panel.

Clarity was used to bring out the details in the hills.

ISO 400
1/160 sec.
f/9
24mm lens

STARTING OFF WITH THE BOOK MODULE

There are many ways to use the Book module in Lightroom, in large part because of all the options available for customizing your project. Unfortunately, to cover every possible option would use most of the pages available in this book. So instead, let's lay out a book project from beginning to end so that you can see just how easy it is. Then, when you get to the end of the chapter, you can start exploring the different options and start creating your own book.

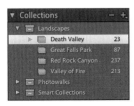

FIGURE 6.1
Creating a collection is the easiest way to start making a book.

BEGIN WITH A COLLECTION

The easiest way to start creating a photo book is to organize the images that you want included into a collection. When you open the Book module by clicking its name in the Module Picker, you'll find the Collections in the left panel along with a preview window. By organizing all the photos you want to use into one collection, you'll have a much easier time accessing them (**Figure 6.1**). Of course, you could use another method, like flagging or keywords, but I find that creating a collection first is the easiest way to organize my photos for a book. If you need a quick review on creating collections, flip back to Chapter 2.

VIEWING PHOTOS IN THE FILMSTRIP

Unlike the Library module, which pulls your images into the Grid for viewing, when you select your collection from the Collections panel, the images will appear in the Filmstrip at the bottom of the screen. From there you can slide side to side and see all of the images available to you to place into your book. If you don't see the Filmstrip, it is probably in auto-hide mode. To show it, you can either click the small reveal triangle at the bottom of the screen or press Shift+Tab a couple of times.

> **TIP**
>
> You can make the photos in the Filmstrip larger by placing your cursor between the Filmstrip and the preview window until it turns into an up and down facing arrow. Then click and drag upward to increase the size of your thumbnails.

CHOOSING YOUR BOOK SETTINGS

You'll first need to decide whether or not you'll be creating a Blurb book or saving your project as a PDF file. I prefer to choose the Blurb book because I can always save it as a PDF when I am done, and if I choose to have it printed, my preferences are already set up. After choosing Blurb in the Book Settings panel (**Figure 6.2**), you should set the other options too. The most important setting is probably the size of the book. The Blurb books come in five different sizes—from 7x7 inches up to 12x12 inches. Three landscape-oriented books fall in between the smallest and largest settings. It's important to remember that book size will be one of the main determining factors in the price of your printed book. Lightroom offers a cost estimate for you at the bottom of the panel so you can keep track of the costs.

If you change book sizes after you start laying out your book, a warning screen will appear indicating that some of your content may not fit after migrating to the new size (**Figure 6.3**). That's why I like to choose my book size before I start the layout process. For this project, I'll choose the Large Landscape book (13x11 inches) with a Hardcover Image Wrap using Premium Lustre paper. The Logo Page option includes a blank page at the end of the book with the Blurb logo. You can deselect this option to not include the logo page, but you get a slight discount for having it in there.

FIGURE 6.2
You can choose to print a Blurb book or choose PDF in the Book Settings panel.

FIGURE 6.3
If you change your book layout, you will be warned about possibly losing content.

SET YOUR PREFERENCES

While setting your options, it's a good time to also set the book preferences by clicking the Book menu option and then clicking Book Preferences. There aren't a whole lot of preferences to set, but it's best to set them before you start working on your first book. You can always alter the preferences in the book layout if you need to (**Figure 6.4**).

FIGURE 6.4
The Book Preferences dialog.

The first preference includes the Layout Options. In the Default Photo Zoom setting, you can choose between Zoom to Fill or Zoom to Fit. I prefer the Fit option to ensure that my photos don't get cropped inside of a window. I can always enlarge them in the layout later on if I want them to fill the cell.

Next, you'll need to decide on whether to select the Autofill option. If it is enabled, Lightroom will use the Auto Layout settings and populate your book automatically with however many pages are needed for the number of photos you have. So if you have the Auto Layout set to two photos per page and you have 24 photos, it will automatically open 12 pages and fill them with your images. I prefer to leave this deselected and create my book layout as I go. You can always go back after autofilling and change the layout if you want.

The third preference includes the Text Options. Some of the page layouts let you add text along with your photos. You have three choices for how the book handles any text that you want to include with your layouts. The first is to add Filler Text. This is just a placeholder and will not appear in your final book if you choose not to use any text. The second will fill text blocks with any Title metadata that you have, like a filename. The third option will fill the text with caption metadata. You can use this option if you've already created captions for your images in the metadata section of the Library. I prefer to add text as I go, so I leave this preference set to Filler Text.

After setting all the preferences, just close the window. There is no Save button to worry about. You can also go back at any time and change your preferences to suit your needs.

USING AUTO LAYOUT

Earlier I mentioned that I like to manually lay out my book pages, but let's start with the Auto Layout option so you see how to set it up as well. If you click the Auto Layout panel, you'll find that there isn't much to it, at least on the surface. There are two buttons to choose from—one to start the Auto Layout process and one to clear any layouts that you may have already begun. The key to using this feature is to make sure you are using the right preset. Click Presets to see the options you have to choose from. You can alter these presets by clicking the preset name and then selecting Edit Auto Layout Preset (**Figure 6.5**).

When the Preset Editor dialog opens, you'll see that it is divided into two halves (left and right). These represent the left- and right-facing pages in your book. These page settings will reflect whatever the current preset is that is listed in the Presets drop-down list. You can choose another preset if you like or start modifying the pages as desired.

FIGURE 6.5
You can use one of the preset layouts or edit any of them to fit your needs.

Each page has four layout options to choose from. You can choose Fixed Layout, which lets you determine the way a layout will look by choosing it from the examples. Just choose the number of photos to use, and you'll be presented with a number of layout choices for the page (**Figure 6.6**).

If you select Random From Favorites, you'll be able to choose the number of photos you want to use, which can be one, two, three, or four images, or any combination thereof (see the next section, "Selecting Favorite Layouts"). Select the check box, and the Auto Layout will randomly select one of the appropriate layouts while mixing and matching the number of photos used, assuming you have more than one image (**Figure 6.7**).

FIGURE 6.6
Fixed Layout lets you choose exactly which layout to use.

With these two options you have some additional layout choices that you can make. One is whether to fill or fit your photos, and the other is whether to (and how to) add captions. Just choose the options appropriate for your project (**Figure 6.8**).

The other two page layout options for Auto Layout are Same as Left (or Right, depending on which page side you are laying out). This option will mirror the choices from the opposite page layout. The other option is Blank Page, which is pretty self-explanatory.

When you are done creating your edited page layout, save and then name it so it appears in the Auto Layout Preset list for you to select.

FIGURE 6.8
You can select the default way that images are inserted into the layouts, fill or fit.

FIGURE 6.7
Choose the number of photos you want to use with the Favorites preset.

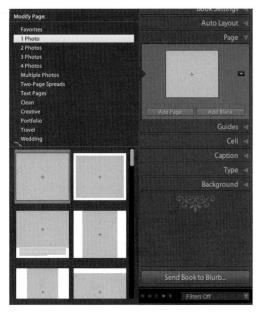

FIGURE 6.9

Click the disclosure triangle to see the layout options.

FIGURE 6.10

Control-click or right-click on a layout and make it a favorite.

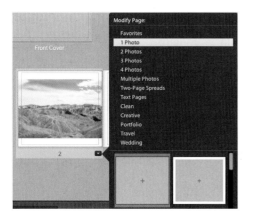

FIGURE 6.11

Moving a photo into a cell can make it easier to see the different layouts.

SELECTING FAVORITE LAYOUTS

To have Auto Layout populate your pages using the Random From Favorites option, you first need to add some favorites. You can do this in a couple of ways. One way is to go to the Page panel and click the disclosure triangle (it's that small down-facing triangle to the right of the layout). A window opens that displays all the available layouts (**Figure 6.9**). Select the number of images you want the layout to contain, and then scroll down through the different options. When you see one you like, Control-click or right-click on it and choose Add Layout To Favorites (**Figure 6.10**).

The other way to do this is almost the same except rather than clicking the Pages panel, click the disclosure triangle on the layout in the preview window. The same layout preview panel found in the Page panel opens. Click the number of photos, and Control-click or right-click to add it to the favorites list.

I prefer this method because I like to drag a photo into the actual layout preview so that I can see just how it will look with a photo in it. If it requires two photos, I pick one from the two-photo layouts and drag two photos in from the Filmstrip. It is easier for me to visualize the layouts when they have photos in them (**Figure 6.11**). To make it even easier to see the layout, look at it in Single-Page view by pressing Command+T (Ctrl+T) (**Figure 6.12**). To go back to the Multi-Page view, press Command+E (Ctrl+E). When you are done looking at the photos in the layout, you can click on them and then press Delete (Backspace) to remove them from the layout.

TIP

Remember that you need to have favorites selected that will cover the number of prints you decided on when setting up your preset. If you selected the check box to add four favorites, you'll need to add at least one four-image layout to your favorites list; otherwise, you will get an error message.

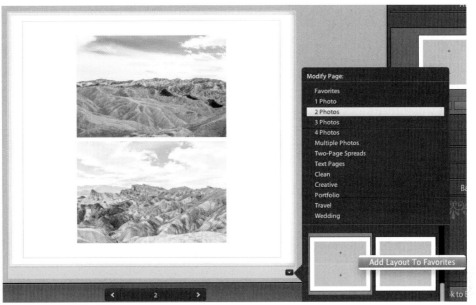

FIGURE 6.12
Use the Single-Page view to get a better look at the layout.

MANUAL LAYOUTS

For this book, let's have a full-page image on the cover and text on top of the image. Select that layout from the Cover layouts. You can browse these layouts by clicking the disclosure triangle on the cover layout preview (**Figure 6.13**). After selecting the cover layout, make it larger by pressing Command+R (Ctrl+R) to switch the preview to Spread view. You can then see both the front and back cover of the book, or a two-page spread if you're looking at the interior pages.

Because you selected a text layout, a text box is available that you can click in to add the book title. The text is fairly small in the layout, which is OK because you'll change it using the Type panel.

FIGURE 6.13
Reveal alternate book cover layouts by clicking the disclosure triangle.

CUSTOMIZING TEXT

Customizing text in the Book module is really no different than using a word processing program. The Type panel has some preset options that you can choose from, or you can just start making changes to the options. If you've already entered some type in the text box, you'll need to select it by clicking and dragging across the text prior to changing any of the Type options. Once the text is selected, you can change the Font type and weight, the color, size, and even opacity.

At the bottom of the panel are several justification blocks for you to choose from with many available options. For even more advanced options, click the panel expansion triangle located to the right of the font color picker block (**Figure 6.14**). These type options work for any text that you have in the book, not just on the front and back covers.

FIGURE 6.14
The Type panel allows you to change all of the type properties.

For this book, I chose the Postino Std font with a size of 62.4 points and center justification. You may have different fonts than I do, so you need to choose from the list that you have.

MATCHING THE FONT COLOR TO YOUR COVER PHOTO

Here is a great little trick for using a color in your cover image as the color of the font in your book title. To start, select the text of your title, and then click the color picker box to open the color palette. With the color palette open, move your cursor inside until it turns into an eyedropper. Here's the fun part: Click and drag the eyedropper out of the color palette and over a color in the image that you want to use for the text; then let go of the mouse button (**Figure 6.15**). The picker will select whatever color the eyedropper is hovering over.

FIGURE 6.15
Make your text color the same as a color in your photo with the eyedropper.

MAKE SOME SPACE WITH CELL PADDING

If you want to change the position of the text in the text title area, you can use the Padding sliders. Padding adjusts the amount of space between an object and the cell. In this case, let's move the text down. Click the panel expansion triangle to reveal the additional padding options. To change only the top padding, click the Link All box to unlink the four sliders and then click Top to activate it. Then all you have to do is move the slider to adjust the padding for the text (**Figure 6.16**).

FIGURE 6.16
Change the padding to move the text within the cell.

Cell Padding also works if you want to adjust the padding for a photograph in a layout cell. The sliders can be adjusted individually, but if they are all linked together, the padding will be added equally to all sides.

ADJUSTING IMAGE SIZES IN THE CELLS

Even though the photos were set to fit inside the cells instead of filling them, there might be times when you want them to fill. This doesn't mean that the preferences need to be changed. Instead, options are available inside the layout view that will let you make these adjustments. For example, the cover layout in the book example calls for a full-page image, but the image is fitting inside the cell and needs to be stretched. To change the option from Fit to Fill, Control-click or right-click on the image and then choose Zoom Photo To Fill Cell (**Figure 6.17**). This will stretch the photo in whatever direction is necessary to fill the cell. You can click and move the image around in the cell to position it the way you want. If you want the image to be larger (or smaller) than the Fill option, you can move the Zoom adjustment slider. It will appear above your image whenever you click on a photo in a layout cell (**Figure 6.18**).

FIGURE 6.17
You can change the image from fit to fill by Control-clicking or right-clicking on it.

FIGURE 6.18
When you click on an image, a Zoom resizing slider appears above it.

SAVING YOUR PROJECT

Before you start making more layout changes and populating the book with photos and text, it's probably a good time to save the book. The document bar above the layout preview window shows you the status of your book (**Figure 6.19**). If you have not yet saved the book, the words Unsaved Book appear to the left of the bar. Saving the book allows you to quickly access it in your Collections panel later on. Also, after you save your book, you never have to save it again. Lightroom will continually update the saved file with every change you make. Also, if you want to create two versions of your book, you can save it with a different name and take your layout in a completely different direction.

FIGURE 6.19
The document bar indicates whether or not you have saved your book.

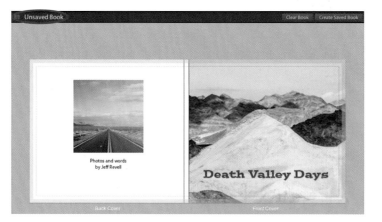

To save the book, click the Book menu and then choose Create Saved Book. You can also save by pressing Command+S (Ctrl+S).

When the Save dialog opens, name your book project. Then decide if you want it to appear next to your collection or actually reside inside your collection, which is like a subset of the collection. In the Book Options section, you can decide which photos will be included with your saved book. I deselect this option because I want to see all of the photos that I plan on using in the book. If the option is selected, only the photos that are already placed in the layout will appear in the Filmstrip.

FIGURE 6.20
The Create Book options dialog.

This doesn't mean you can't add more; it's just more of a convenience thing. There is also an option to create virtual copies of the images you are using. This can be handy if you want to edit the images for the book but don't want those edits to be applied to the regular images in the library. I typically leave this option deselected as well (**Figure 6.20**). After you've saved your book, its name appears in the document bar as well as the Collections panel.

TIP

Aside from tracking all of your layout changes, there is another benefit to saving your book project. Before saving, you cannot reorder the images in the Filmstrip. However, after saving, you can drag them around and place them in the order that you want them to appear in the book. This can be a big time-saver, especially if you'll have Lightroom auto fill your pages.

ADDING PAGES TO THE LAYOUT

Up to this point, you've done a lot of preparation for the book, but now it's time for the fun part—laying out the pages. When you start a new book, you begin with a front/back cover layout, one interior page, and a back page. If you use the Auto Layout option, Lightroom will add however many pages are needed to accommodate the number of images in your Filmstrip. However, if you choose to manually lay out your book, you'll need to add pages, choose the layout, and add the photos.

Let's start by changing the layout of the first page. To do this, click the disclosure triangle to reveal the layout options and then select the layout that you want (**Figure 6.21**). For this example, choose a horizontal image with a text block next to

FIGURE 6.21
The default page layout is changed to one with text.

FIGURE 6.22
A single image layout with a text cell.

FIGURE 6.23
You can add new pages to the layout in the Page panel.

it. After selecting the new page layout, drag a photo from the Filmstrip into the photo cell and then add the type you want to the page (**Figure 6.22**).

Because there is only one default page, it is necessary to add more. You can Control-click or right-click on the page and choose to add a page, but this would add the new page in front of the currently selected page. Instead, select the current page layout by clicking on it (selected pages have a yellow border around them), go to the Page panel, and click Add Page or Add Blank (**Figure 6.23**). Add Page adds a page with the same layout as the previous page, which is why I prefer to add a blank page and then select the layout I want. Clicking either choice will add a new two-page spread into your layout view. However, if you are adding a page in the middle of the book, adding a page will just add one photo page to the layout. Then it's just a matter of setting the page layout, adding photos from the Filmstrip, and annotating any text that needs to be added.

SPANNING TWO PAGES

There may be times when you have a photo that you really want to see in a large-size spread across two pages. For those instances, you can select from quite a few two-page spread options. Click the disclosure triangle at the bottom of your layout page and then click the Two-Page Spreads collection. Several different options are available to choose from, including multi-photo options. Just be sure that the photo you choose is of a high enough quality to use in a two-page spread. I usually use a two-page spread for showing off my panorama images (**Figure 6.24**).

FIGURE 6.24
Panorama photos look great as two-page spreads.

TIME TO REARRANGE

As you start adding photos to your layout, the thumbnails will be tagged with a number in the Filmstrip. This number indicates if the image has been added to the book and if so how many times it has been used (**Figure 6.25**). As mentioned earlier, you can rearrange your images in the Filmstrip after you've saved your book project, but you can rearrange them inside the page layouts as well.

After moving your photos into the page layouts, you may decide that you want to move images around a bit by moving a photo from one page to another. This is easily done by clicking the image in one page and dragging and dropping it in a photo cell on a different page (**Figure 6.26**). You can also drag and drop images within a single page if you have multiple images in the page layout. The image that was in the photo cell will switch places with the image that you are moving.

FIGURE 6.25
The Filmstrip helps you keep track of which photos have been added to the layout.

FIGURE 6.26
You can easily rearrange photos by dragging them from one page to another.

FIGURE 6.27
You can drag entire pages around the layout and drop them in a new location.

You aren't just limited to moving images. If you want to reorder the pages in your book, click on the page you want to move to select it and then drag it by clicking on the page number and moving it to the desired location. A yellow line appears between the pages where the page will land when you release the mouse button (**Figure 6.27**).

TIP

If you want to adjust a book photo in the Develop module, just highlight it in the layout or in the Filmstrip and press D. When you're done with your edits, click Book in the Module Picker to go back to your layout.

FINISHING TOUCHES

Even though the bulk of the book creating process is done at this point, there are a few enhancements you can make to the look and content. I generally like to lay out my entire book and then go back and make small additions, like adding captions or labels. It helps me to see the project as a whole so I know where I want to make some minor additions.

FIGURE 6.28
Use the Caption panel to add a caption to your photos and pages.

ADDING CAPTIONS

You can add captions to any of your photos or pages at any time in your layout process by using the Caption panel. The panel offers two options for adding a caption. You can add captions to photos, pages, or both if you desire. Adding captions is pretty simple. If you want to add a caption to a photo, click the photo cell that you want to apply the caption to and then select the Photo Caption check box to add a text box for the caption. You can select the Offset value (to indicate how far away the text is from the photo), whether or not to align the caption with the photo, and where the caption will appear in relation to the photo (**Figure 6.28**).

The page captions are similar to the photo captions, but they can only appear at the top or the bottom of the page. You can modify the text in the captions by using the options in the Type panel.

BACKSCREENING AND BACKGROUNDS

Another great way to dress up your pages is to add a background graphic, a backscreened photo, or even a background color for the page. All of these items can be added using the Background panel and can be applied to individual pages or globally to every page in the book. To apply an effect globally, select the Apply Background Globally check box. Be sure to clear the check mark if you want to apply the effect only to individual pages.

If you want to use a photo as a background graphic, drag it into the box in the Background panel. This is referred to as backscreening, and it is generally most effective when you lower the opacity of the background photo to about 20%. One neat effect using this method is to choose a single small photo to display on a page and then use the same image as a backscreen. This is extremely popular for wedding albums, but looks good with other subjects as well (**Figure 6.29**).

FIGURE 6.29

Adding a backscreen image is accomplished in the Background panel.

A number of pretty nice background graphics are provided for you to use in your travel or wedding books. Click the disclosure triangle in the Background panel, select either the Travel or Wedding group, and then choose the graphic you want to apply to your images. The Travel group includes some appealing map-type graphics, and the Wedding graphics include some attractive accent swirls. As with the backscreen photo, you can apply these backgrounds to individual pages or globally to the entire book.

ADDING A SPLASH OF COLOR

Another option in the Background panel is Background color. This is similar to selecting text color in that when you select the check box and then click in the color box, a color palette opens along with an eyedropper for you to select your color of choice. You can move the vertical slider on the right side of the palette to change the saturation level (it starts off gray, so move the slider up to reveal some color choices). You can also use the little trick you learned earlier in the chapter and click the eyedropper in the palette and then drag it onto the photo. Then you can use a color from your image as a background color (**Figure 6.30**). You can also use the background color to set all the page colors to black or dark gray for a professional portfolio look.

FIGURE 6.30
The background color can be taken directly from an image using the eyedropper.

UPLOADING YOUR PROJECT

When you've completed the layout of your book, all that's left to do is send it on its way to Blurb. When you click the Send Book to Blurb button, a sign-in dialog opens. If you've already signed up for Blurb printing services, all you need to do is enter your email address and password, and then click Sign In (**Figure 6.31**). If you aren't a member, click the Not a Member link in the lower-left corner to set up your account. When the registration dialog opens, enter your email, a username, and a password, and then click Register (**Figure 6.32**).

After you've registered, you'll need to add one more bit of information before uploading your book. In the final Blurb dialog, enter your book title, the subtitle if you have one, and the author's name (**Figure 6.33**). Finally, click the Upload Book button and Lightroom will start to render your layout into images and upload the project to the Blurb servers for processing. When the book has been processed, you'll be taken to the Blurb website where you can preview your book and finalize the purchase (**Figure 6.34**).

FIGURE 6.31
You must sign in to Blurb to send in the book for printing.

FIGURE 6.32
If you don't have an account, you must register using this dialog.

FIGURE 6.33
Fill in your book title and author info before starting the upload process.

FIGURE 6.34
After the book is uploaded, you must complete the purchase on the Blurb website.

CREATING A PDF

Even though you set up this book for Blurb printing at the beginning of the chapter, you can still save an electronic copy without having to change any of the settings. In the lower portion of the left panel, click the Export Book to PDF button. A Save dialog opens where you specify the filename and destination to save to. Lightroom then begins the rendering process and compiles the final images into a single PDF file that you can share with friends and family. You could even sell it!

Chapter 6 Assignments

Creating a photo book isn't just about showing off your pictures. It's about creating a story. The best part is that you get to be the author and illustrator, and you can take the book in any direction you want. Making books is not only fun, it's also a great tool to help you become a better storyteller through your photography.

Start with a Collection

When creating a book, it's best to start with a collection. Try making a Smart Collection and use a red color label as your criterion for automatically adding images to the Smart Collection. Then review your images. When you see one you want in your book, click on the photo to select it and press the number 6 to apply the red label and add it to your collection.

Try an Auto Layout

I enjoy laying out my own books, but sometimes it's fun to let the program do it for you just to see what it comes up with. Try Auto Layout. It can give you a good place to start.

Try Some Creative Layouts

Someone at Adobe took the time to make some pretty amazing layouts. Try using one of the two-page spreads and setting your image to fill the page. Or, check out some of the framed layouts. They look amazing and can add some real flair to your books.

Get a Book Printed

Seriously, why go though all the effort of laying out a book without ever printing one? You don't have to spring for the big-dollar, max-size book. Try making a little 7x7, softcover, coffee table book. The cost is pretty reasonable, and you'll love being able to show off your printed photo book to your friends and family.

Share your results with the book's Flickr group!

Join the group here: flickr.com/groups/photoshoplightroomfromsnapshotstogreatshots

7

ISO 400
1/13 sec.
f/5.6
55mm lens

The Print Module

MAKING GREAT-LOOKING PRINTS AT HOME

A few years back, a good friend was visiting my home for the first time. I gave him the grand tour, and when we were done, he asked, "You take so many great photos, why don't you have any of them hanging on your walls?" I hadn't given it much thought up to that time, but I did from that point on. Move forward a couple of years, and I have my photos hanging all over the place. One of the main reasons I love printing now is due in large part to the Lightroom Print module. It is a fantastic tool for exploring all sorts of print layouts, not just the common 8x10 center print on a piece of photo paper. It can still do that if you want, but why limit your possibilities with all the printing options Lightroom has to offer?

PORING OVER THE PICTURE

The Shadow slider was used heavily to brighten the shaded buildings.

San Francisco is one of the most photogenic cities I've ever visited. It's difficult to take the camera away from my eye with such a wide variety of subject matter to capture. While walking some of the hilly streets near Chinatown this particular day, I heard the clang of a cable car bell. So, I found a good spot on the corner and waited. I thought I'd see just one car, but my timing was perfect, and I was treated to a double dose of cable cars. Thirty seconds later they were both gone.

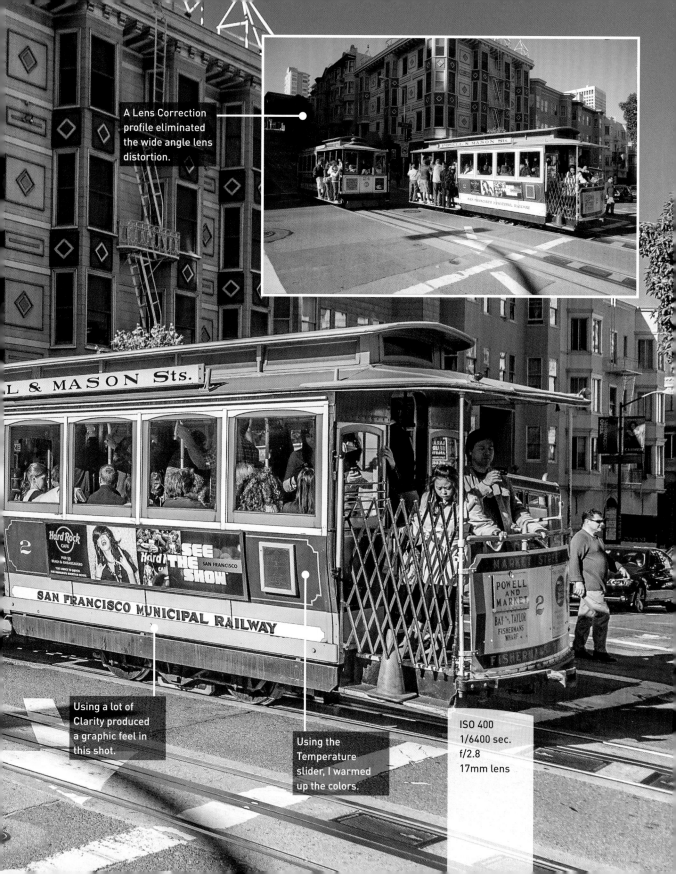

A Lens Correction profile eliminated the wide angle lens distortion.

Using a lot of Clarity produced a graphic feel in this shot.

Using the Temperature slider, I warmed up the colors.

ISO 400
1/6400 sec.
f/2.8
17mm lens

PREPPING FOR THE PRINT

Before heading to the Print module, you first need to identify the photo(s) you want to print. You can do this in a variety of ways, but one of the easiest is to make a collection. Some photographers sort their images into collections and then make subsets inside the collections of images that they want to print. It's an easy way to organize your images, and because the Collections panel is always available from the Print module, it's easy to access them as well.

TRY A QUICK COLLECTION

Creating a print collection isn't a requirement, however, because you can take any image into the Print module. If an image is visible in the Grid view of the Library, it will be visible in the Filmstrip at the bottom of the Print module. Of course, if you have lots of photos in the catalog, it might be difficult to find the ones you want in the Filmstrip, which is why I like to create a Quick Collection for printing. The Quick Collection isn't permanent, but it is an easy way to temporarily group photos that I want to work with. Remember that all you need to do to add an image to the Quick Collection is to select it and press the B key.

Once you have all of the photos grouped into the Quick Collection, all you have to do is click Quick Collection in the Catalog panel. This will filter out all other photos and make those in the Quick Collection active in the Library (**Figure 7.1**). With the collection active, you can hop to the Print module by clicking the word Print in the Module Picker and then access the photos in the Filmstrip (**Figure 7.2**). The only downside to the Quick Collection is that you can't select it from the Collections panel, so make sure you click it prior to moving into the Print module.

SHARPENING FOR PRINTS

Sharpening for a print is different than sharpening for onscreen use. You'll need to apply more sharpening than you think is necessary when making an inkjet print. The reason is that when a print is made, the ink that is laid out on the photo paper has a tendency to spread slightly as it soaks into the paper fibers. There can also be a difference in the paper material in relation to the amount of sharpening needed. Glossy papers tend to hold the ink together well, so less sharpening is needed. Matte or fiber papers allow the ink to spread more and require more sharpening. You'll need to test the type of paper you use to see how much sharpening you need when making your own prints.

FIGURE 7.1
Use a Quick Collec-
tion to identify the
photos you want to
work on in the Print
module.

FIGURE 7.2
Images will be
accessible in the
Filmstrip.

START WITH A TEMPLATE

It's difficult to know exactly where to begin in the Print module. There are so many panels to choose from that it can seem a bit overwhelming at first. That's why Adobe has given you several templates to start with. A template is similar to the presets that you've used in other areas of the program. It has all of the necessary settings to create a variety of print looks, but each can be changed and altered to your needs.

LIGHTROOM TEMPLATES

To access the templates, click the disclosure triangle in the Lightroom Template section of the Template Browser panel to reveal a large collection of templates to choose from (**Figure 7.3**). Some of the templates are made to work with a single image; others are made for printing multiple images on the same page. To preview the general layout of a template, just hover your mouse over the name and look at the Preview panel located above the browser. This will give you a good indication of the general layout. If you click the template name, whichever image is actively selected in the Filmstrip will be displayed in the main print layout window with the template applied (**Figure 7.4**).

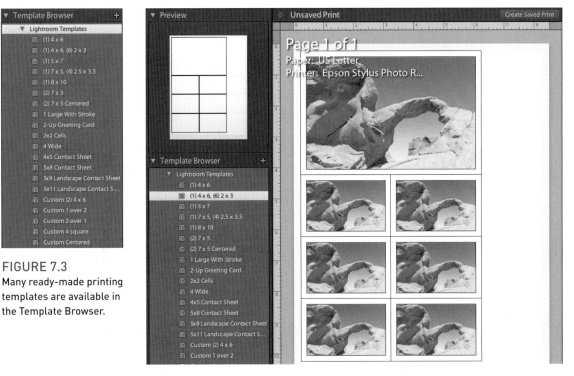

FIGURE 7.3
Many ready-made printing templates are available in the Template Browser.

FIGURE 7.4
Select an image from the Filmstrip, and then click a template name to see the layout.

WORKING IN SOLO MODE

Scrolling up and down through the different panels in the Print module can get a little tedious. So, I always put my panels in Solo Mode, which makes only the active panel visible. To place your panels in Solo Mode, Control-click or right-click the Panel End Mark below the bottom panel and then select Solo Mode (**Figure 7.5**). Now when you click a different panel title, that panel will expand and the others will close.

FIGURE 7.5
Put your panels in Solo Mode to hide inactive panels.

CUSTOMIZING A TEMPLATE

Not every template will totally satisfy your printing needs. You'll undoubtedly need to make some changes in the size or even in the positioning of the photo on the page. You can easily change the look of the print using the layout tools located in the right panel.

Let's start by modifying a simple print template. Choose one of the Lightroom templates for printing a single photo, like (1) 8x10. This template fills the 8x10 print area with a single image. If you look at the Info Overlay in the top-left part of the layout window, you can see that it is set for Print 1 of 1 with the paper size set to US Letter and the Printer set to my Epson (**Figure 7.6**). A quick look at the Layout panel shows that the margins are set for .25 inches except at the bottom, which is set to .56 inches. The Page Grid is set to 1 Row and 1 Column. This means that there is only one print cell for this page. Below that you can see that the cell size is set to 8x10 inches (**Figure 7.7**).

CHANGING THE PAPER SIZE

Not everyone has more than one printer like I do, but that doesn't mean you can't change the size of the paper you are using. Lots of different paper sizes and styles are available for all types of output, from printing greeting cards to making standard 4x6 prints. To use them, you'll need to change the Page Setup and possibly

FIGURE 7.6
The Info Overlay displays print information on your layout.

FIGURE 7.7
Vital information about print cell sizes and margins is located in the Layout panel.

the Print Settings. These options are available by clicking the appropriate button located at the bottom of the left panel. For my 8x10, I want to make a large print, so I'll start with the Page Setup.

Click the Page Setup button to open the options dialog.

On the Mac, I'll set the Format For option to the Epson R3000 printer and then change the Paper Size to Super B. This is a 13x19-inch paper that is a perfect size for all sorts of large prints. I'll also switch the image Orientation option from portrait to landscape (**Figure 7.8**).

If you're working in a Windows environment, you'll only have a Page Setup button. Clicking this button in Windows brings up all of the print settings that I just changed plus a Properties button to make changes to the printer settings (**Figure 7.9**).

When you've made all the changes I just described, click OK. The layout of the print will look much different: The image will be in landscape mode inside a larger page (**Figure 7.10**).

To change the print cell to a larger size, click the Layout panel. Increase the Cell Size at the bottom of the panel to the desired size, like 11x14 (**Figure 7.11**).

Save these settings as a User Template so that you can use them again in the future without having to go back to the Print Settings or Layout panel.

FIGURE 7.8
The Page Setup dialog in Mac OS 10.7.

FIGURE 7.9
The Windows 7 Print Setup dialog.

FIGURE 7.10
Changes to paper size and orientation will be reflected in the layout window.

CREATING A USER TEMPLATE

Follow these steps to create a custom User Template:

1. Click the plus (+) symbol at the top of the Template Browser on the right side of the title bar (**Figure 7.12**).

2. Name the new template and select the location to save it to (**Figure 7.13**). You can use the default User Templates location or create a new folder.

3. Access the new template by clicking it in the Template Browser (**Figure 7.14**).

If at any time you make changes to the template and want to save them as part of your template, Control-click or right-click the template name and choose Update with Current Settings (**Figure 7.15**).

FIGURE 7.11
You can adjust the size of the print cell in the Layout panel.

FIGURE 7.12
Click the plus (+) symbol to save a template.

FIGURE 7.13
Choose a descriptive name for your template.

FIGURE 7.14
Saved templates are accessible in the Template Browser.

FIGURE 7.15
You can update your template if you make any modifications to the layout.

One of the reasons that the templates are so useful is that they can be constantly changed or modified and then saved as new templates, making them extremely quick to get to and easy to use.

PRINTING DIFFERENT PHOTOS ON ONE PAGE

Some of the Lightroom presets have been created to allow you to include different photos on one printed page. These typically have more than one print cell in the layout and are set to Single Image/Contact Sheet in the Layout Style.

Using them is pretty easy: Click the template, like the 2x2 Cells, and then Command-click (Ctrl-click) four different photos in your Filmstrip to add them to the sheet (**Figure 7.16**). To customize the layout a bit, you could open the Page Setup dialog, change the orientation to Landscape, and select Zoom to Fill in the Image Settings panel. Then save this as a new preset called 2x2 Landscape with Fill (**Figure 7.17**).

You can change the order in which the images appear in the print cells. To rearrange the images, click and drag the photos in your Filmstrip to order the images. The cells fill from left to right and from top to bottom (**Figure 7.18**).

FIGURE 7.16
You can print different photos on the same page with the right template.

FIGURE 7.17
You can change existing templates and resave them as new ones.

FIGURE 7.18
You can change the order of your photos by dragging them to a new location in the Filmstrip.

PRINTING A PICTURE PACKAGE

Remember when you would get your elementary school pictures in those packages that had some 5x7s, 2x3s, and lots of wallet-sized photos all on one sheet? Well that was a picture package, and you can print one automatically in Lightroom with the help of a template.

The picture package in **Figure 7.19** consists of one 5x7 and four 2½ x 3½ photos. This is one of the layouts in the Lightroom Templates. The Cells panel offers more options to add to this package. This gives you a lot of flexibility to offer different-sized packages to friends and family. If you want to add an 8x10 to the package, just click the 8x10 button and an additional page is created that includes an 8x10 print. You can keep adding photos in different sizes, and Lightroom will keep adding pages, automatically laying out your new package pages (**Figure 7.20**).

If you want to eliminate a package page, just move your mouse over it and then click the red X that appears in the upper-left corner of the page.

FIGURE 7.19
The Print module allows you to create completely customized picture packages.

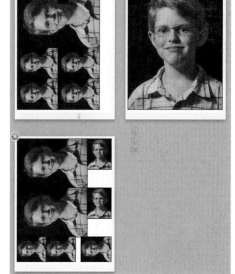

FIGURE 7.20
You can add additional pages to a package, each with custom sizes.

CREATING A NEW CUSTOM PACKAGE

You don't have to use one of the template packages. If you prefer, you can build your own package from scratch.

1. In the Layout Style panel click Custom Package.

2. In the Cells panel, if there are already cells in the layout, click the Clear Layout button.

3. If the page size is not correct, click the Page Setup button and set the Paper Size.

4. In the Add Package section in the Cells panel, start adding the sizes of the prints that you want to include.

5. Drag in the photo that you want to appear in each cell, and it will automatically be sized correctly (**Figure 7.21**).

FIGURE 7.21
Photos will be automatically placed in the correct orientation when you drag them in.

6. If you want to use the layout again in the future, save the layout as a new User Template.

You might want to create a new folder and call it Packages so you can quickly navigate to any packages you have created.

ADDING SOME FLAIR

A few features in the Print module, such as the custom packages, let you create truly unique prints. You aren't just limited to the size of the cells, though. You can also add some finishing touches, like adding a stroke or branding your images with an Identity Plate or logo.

ADDING A STROKE

It's not always necessary to add a border around your prints, but sometimes it can add a nice accent to put a stroke around the photo. A stroke is like a border, and you can set the thickness and the color.

1. Before adding a stroke, turn off all the guides so that it is easier to see the stroke in the image. To do this, press Shift+Command+G (Shift+Ctrl+G).

2. In the Image Settings panel select Stroke Border.

3. Change the color by clicking in the color box and then selecting a color from the palette (remember that you can use the eyedropper trick to pick a color from the photo).

4. Choose a border thickness using the Width slider (**Figure 7.22**).

FIGURE 7.22
You can add a stroke/border around your image in the Image Settings panel.

ADD SOME IDENTITY TO YOUR PRINTS

Adding some design text to your prints can really turn a snapshot into a fantastic shot. The Identity Plate option lets you place a title under your image or use your studio logo to advertise yourself. I actually saw an Identity Plate graphic used as a border effect. You are only limited by your imagination.

1. To create a simple Identity Plate, set up your photo layout and then click the Page panel.

2. Select the Identity Plate check box.

3. Click inside the large box with text in it (it might display the word Lightroom or even your name), and then choose Edit from the pop-up menu (**Figure 7.23**).

FIGURE 7.23
To change the Identity Plate, click in the text box and choose Edit.

4. Type your text in the Identity Plate Editor and adjust the font type. Don't worry about changing the size or the color of the font. You'll do that next. Click OK when you're finished (**Figure 7.24**).

5. Click on the Identity Plate in the photo layout, and then drag the corners to resize it. To move the plate, place your cursor inside the plate and then drag it around the layout (**Figure 7.25**).

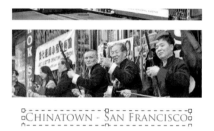

FIGURE 7.24
Edit the text for the new plate and then click OK.

FIGURE 7.25
You can resize your new plate right on your layout by dragging the corners.

6. To change the color, select the Override Color check box in the Page panel, and then select a new color by clicking in the color box.

7. Use the Opacity slider to fade the text. Resize it again if necessary using the Scale slider (**Figure 7.26**).

FIGURE 7.26
You can modify the color and opacity of the Identity Plate in the Page panel.

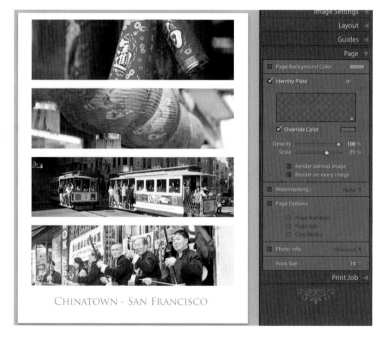

You can also use a graphic as your Identity Plate instead of text. Just open the editor as you did in step 3 or open it by double-clicking on the plate in your image layout. Then select Use Graphical Identity Plate in the Identity Plate Editor and paste or drag an image into the designated space, or click the Locate File button to find it.

Once you have the graphic in place, you can resize it and change the opacity just as you did with the text (**Figure 7.27**).

PROTECT YOUR IMAGES WITH A WATERMARK

A common practice among many photographers who deliver proof images to clients is to add a watermark on the image. It's typically semitransparent and lets customers see the image but prevents them from copying it without giving the photographer credit. It is also used by many photographers who post their work online as a way of identifying themselves as the owner of the image. It's not a foolproof method of preventing image theft, but it does present somewhat of a deterrent while letting people know who to contact for licensed copies.

Adobe added a watermarking feature in Lightroom 3, and it was an instant hit. Using the watermark feature is pretty straightforward, and once you set it up, it is very easy to apply it to future images.

SETTING UP A SIMPLE WATERMARK

The Watermark feature is located in the Page panel and can be added to your image by selecting the Watermark check box. If you have not previously created a watermark, it will be set to None. To get started, you need to create a watermark and add it to the list.

1. Click the word None and then choose Edit Watermarks from the pop-up menu (**Figure 7.28**).

2. At the top of the Watermark Editor, select Text for the Watermark Style (**Figure 7.29**).

3. In the text box beneath the image, type your name or whatever information you want to appear in the watermark.

4. Set your choice of font in the Text Options.

5. To add a drop shadow, select the Shadow check box and adjust the sliders to your liking.

6. In the Watermark Effects panel set the Opacity and size of the watermark.

7. You can adjust the anchor location for the watermark at the bottom of the Effects panel.

FIGURE 7.27
You can also use a graphic or logo for your Identity Plate.

FIGURE 7.28
Create a new watermark by choosing Edit Watermarks from the pop-up menu.

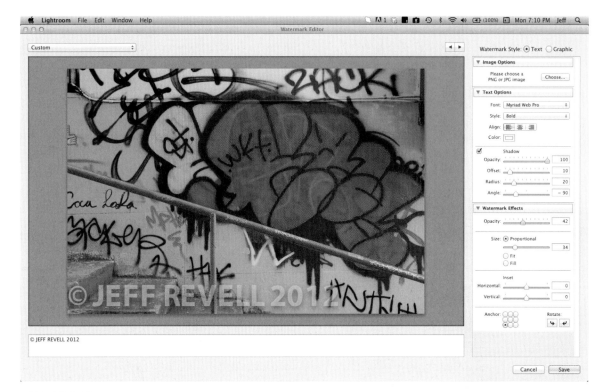

FIGURE 7.29
Set up your new watermark in the Watermark Editor dialog.

8. When you've finished setting up your watermark, click the Save button and name it.

9. Select the new preset in the Watermark section to add it to your prints (**Figure 7.30**).

> **NOTE**
>
> Remember that the watermark should be transparent enough so that it doesn't obscure all the visual information in the image.

TIME TO PRINT

The final step in the Print module is to actually send your photo to the printer, but that's not the only option available. There are also a couple of other tasks that you can perform before putting ink to paper, including saving all the hard work you just did.

FIGURE 7.30
Select your new watermark, and be sure to select the Watermarking check box to add it to your print.

SAVING YOUR PRINTS

As with the Book module in Chapter 6, you have the ability to save all the work you put into creating the perfectly laid out print. A quick look at the top-left side of the document bar indicates whether or not your print is saved (**Figure 7.31**). To save all your changes so you can print the image later, click the Create Saved Print button on the right side of the document bar or press Command+S (Ctrl+S). The Create Print dialog opens prompting you to name your print and place it in or next to a collection (**Figure 7.32**). When you click the Create button, you'll see the addition of your print to the collection. You can then go back and access it at any time (**Figure 7.33**).

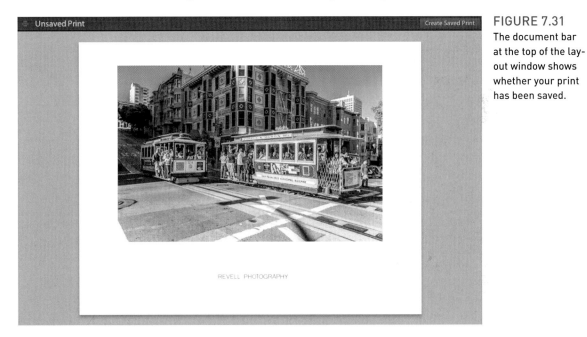

FIGURE 7.31
The document bar at the top of the layout window shows whether your print has been saved.

FIGURE 7.33
You can access your saved print in the Collections panel.

FIGURE 7.32
Type a name for your print and click the Create button.

FIGURE 7.34

Change the Print To setting to JPEG File.

FIGURE 7.35

Set the JPEG options in the Print Job panel.

FIGURE 7.36

Deselect the Print Resolution check box, and let your printer adjust the image resolution for you.

PRINTING TO A FILE

If you would rather make a digital file of your print layout, you can quickly do this by opening the Print Job panel and changing the Print To selection from Printer to JPEG File (**Figure 7.34**). The options in the panel will change, allowing you to set the sharpening, dpi, JPEG Quality, and color profile. I typically leave these options at their default settings and click the Print to File button below the panel (**Figure 7.35**). A Save dialog appears prompting you for a name and location for your saved file. After adding the information, click Save and Lightroom will render a JPEG file complete with all of your print layout options. It's like printing an electronic version of your file that you can then share or send to a printer if you don't want to print it yourself.

SENDING TO YOUR PRINTER

Of course, it's only right that you finish working in the Print module by sending an image to your printer. Remember that your printer and print driver may be completely different from mine, but the general concepts will be the same. To begin the process, go back to the Print To section in the Print Job panel and switch it back to Printer. Skip the Draft Mode printing section, but look at the Print Resolution setup, which is set to 240 ppi by default. My recommendation is that you turn off this setting (**Figure 7.36**). Most of today's printers work better when you let the printer interpolate the resolution depending on the needs of the selected print size.

The Print Sharpening section lets you add sharpening to the final print that is in addition to what you have done in the Develop module. The general rule for Lightroom print sharpening is: Low equals none, Standard is low, and High should be standard. You should probably make a test print to check the accuracy of this rule. You can also select the type of paper surface you'll be printing on, but your choices are limited to Glossy or Matte. The other option that you can set in this section is whether or not to turn on 16 Bit printing. Not all printers support 16 Bit Output, so check your printer documentation before activating this feature.

COLOR MANAGEMENT

Color Management is perhaps the most important section of the Print Job panel because it determines whether the printer or Lightroom is in charge of handling all of the color information during printing. My recommendation is to let Lightroom handle the color management. To do this, you need to

select a color profile for Lightroom to use. In the Profile option, click Managed by Printer and choose Other from the pop-up menu (**Figure 7.37**). A dialog opens with a list of different profiles to choose from.

FIGURE 7.37
Click in the Profile area and choose the proper profile for your printer and paper.

There is a good chance that when you installed your printer, some specific profiles were loaded. If so, you should select the one that is appropriate for the printer and paper you will be using. For example, I like to print on Epson Premium Glossy paper on my Epson R3000 printer, so I would choose that profile (**Figure 7.38**). I can select all of the printer/paper combos that I might use, and they will appear in the color management profile menu the next time I need them. If you don't have any profiles installed, select the Adobe RGB (1998) profile. It is one of the better overall profiles that is made for printing.

FIGURE 7.38
Print profiles are typically created when you install your printer.

Once you've set all your options, you need to do one last bit of housekeeping, which is to turn off color management in your printer preferences. You need to do this so that Lightroom and the printer aren't both trying to color manage your print. If you are using a Mac, Lightroom will sometimes turn it off for you, but it's always a good idea to make sure it's off.

PRINT SETTINGS FOR MAC USERS

Mac users should use the following print settings:

1. Click the Print Settings button at the bottom of the left panel.
2. Click the Layout drop-down menu and choose Print Settings (**Figure 7.39**).
3. Check the Media Type and make sure it is set to the type of paper you will be using.
4. Set the Color Mode to Off (No Color Management) and click Save (**Figure 7.40**).

FIGURE 7.39
Change to Print Settings in the Print Settings dialog on a Mac.

FIGURE 7.40
Make sure the Color Mode is set to Off before printing.

PRINT SETTINGS FOR WINDOWS USERS

Windows users should use the following print settings:

1. Click the Page Setup button at the bottom of the left panel.

2. In the Print Setup dialog, click the Properties button (**Figure 7.41**).

3. Check the Media Type and make sure it is set to the type of paper you will be using.

4. Set the Mode to Off (No Color Adjustment) and click the OK buttons to close the Properties and Setup dialogs (**Figure 7.42**).

5. Click Print and enjoy the fruits of your labor.

FIGURE 7.41

In Windows click the Properties button in the Print Setup dialog.

FIGURE 7.42

Set the paper type and turn off color adjustment in the Properties dialog.

Chapter 7 Assignments

Creating a print means more than just clicking the Print button. To make a quality print that you or someone else would want to hang on the wall, you can't be afraid to be creative. Fortunately, the Print module is designed to help you get the most from your printing experience and help you create images that you might never have dreamed of making before. So jump on in and get printing.

Start with a Template

The easiest way to start working in the Print module is to head on over to the Template Browser and choose a template. Of course, you'll need to have a photo or two ready in the Filmstrip to work with. Try to select at least one horizontal and one vertical image to work with. Select the vertical photo and then start clicking your way through the templates to see how each looks. Then do the same with the horizontal image. Once you know how the templates look, you can start playing.

Modify a Template

One of the advantages of templates is that you can modify them to meet your needs and then save them as your own. Find one that you like and then start moving the cell sliders and margins to see how they affect the layout. When you've set one to the way you want it, save it as a User Template.

Show Your Identity

Using the Identity Plate is a great way to add some flair to your prints. You can put your name on the print or make a cool-looking label for a gallery-type poster. The choice is up to you. Experiment with different fonts and try changing the font size, color, and opacity. When you find a combination that you like, save it as another template, and your Identity Plate will be set up for the next time you want to make a print.

Make a Print

Playing with all the templates is a lot of fun, but let's face it, the goal in the Print module is to put ink to paper and make a great-looking print. If you have a printer, get some good photo paper and put everything you have learned to the test. If you aren't set up for printing, use the Print to File option and then send your image to an online printing service or take it to a local printer and create an art piece for your wall.

Share your results with the book's Flickr group!

Join the group here: flickr.com/groups/photoshoplightroomfromsnapshotstogreatshots

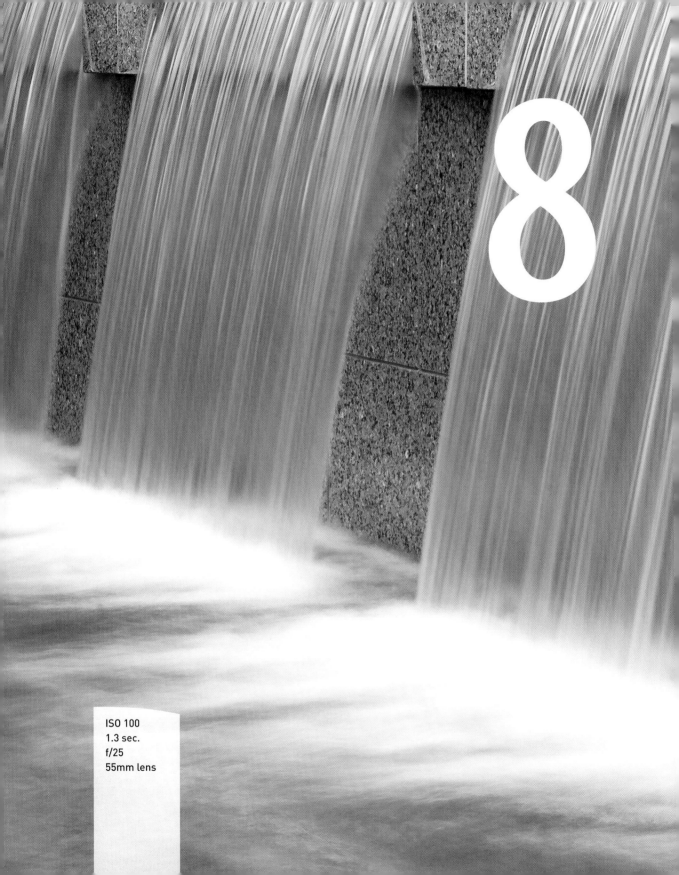

8

ISO 100
1.3 sec.
f/25
55mm lens

Sharing and Exporting

GETTING YOUR WORK OUT OF LIGHTROOM

You have edited and organized, but what fun is it to take pictures and then just squirrel them away on your hard drive? You've worked hard to improve your image editing skills, and this chapter is all about showing them off. One of the wonderful advantages of the digital medium is that you have many options for showing off your work, whether you decide to create an online gallery, make a slide show, or just send folks your photos in an email. Let's take a look at a few of the many options that Lightroom has to offer.

Several dark spots on the wall were removed with the Spot Removal tool.

The artificial lights altered the color, so I changed the shot to a black-and-white image using the Cold Tone preset.

This past fall I led a photowalk around the many monuments in Washington, D.C. It's one of my favorite places to visit, but this was the first time that I had taken a camera into the Lincoln Memorial. A huge crowd was inside, so I chose a long focal length to isolate the statue of Lincoln and used my tripod like a monopod to grab a few quick shots. My capture lacked definition, and the color was a little off from the sodium vapor lights, but I repaired all the image's problems in the Develop module.

Adding Clarity helped define the facial features.

Adjustments were made with a Linear Tone Curve to increase the contrast in the highlights.

ISO 200
1/4 sec.
f/5.3
120mm lens

SHOWING OFF YOUR PHOTOS

You have so many ways to show off your images these days that it's sometimes difficult to choose one. Of course, my philosophy is why settle on one when you can have them all? When you're using Lightroom, you have that option because it is so easy to take your photos from one display method to another. Let's start with some tools that will help you get your photos up on the biggest stage there is, the Internet.

CREATING A WEB GALLERY

The Web module allows you to create two different types of web-style galleries for your images. The first type is a simple HTML gallery, which is not very dynamic in its operation but has the advantage of being visible by almost any web browser. The other gallery style is based on Flash and renders a much more dynamic user experience. The problem with Flash-based galleries is that some browsers may not support Flash. This is especially true if you want your gallery to be visible on an Apple mobile device, such as an iPad or iPhone.

Just as you did with books and printing, the first place to start is with your images. Once again, the easiest method of collecting all of the images for use in the Web module is to create a collection so you can quickly select them from the Collections panel. You can also use the Quick Collection or even flagged or starred items. It really doesn't matter as long as the images you want to use are visible in the Filmstrip. You should know, however, that the Web gallery will use all the images in your Filmstrip, so ensure that you are seeing only the images that you want included.

CHOOSING A GALLERY STYLE

You don't have to be a web designer to create a good-looking web gallery in Lightroom. All you need to know is where the Templates are. Lightroom has a large collection of the ready-to-use templates in the Template Browser. You can mouse over them to see their general design in the Preview panel located just above the Template Browser (**Figure 8.1**). Clicking the template name applies the layout to your images, letting you get a better view of just how the gallery would look in web page format (**Figure 8.2**). It's difficult to tell which templates are HTML and which are Flash, but if you mouse over the name, you can see the type in the lower-left corner of the preview (**Figure 8.3**).

FIGURE 8.1
Mousing over a template shows you a quick preview in the Preview panel.

FIGURE 8.2
Click on a template to see it applied to your images.

FIGURE 8.3
The preview shows you whether you are using an HTML (left) or Flash (right) template.

PERSONALIZING THE GALLERY

After you have selected the gallery style that you like from the templates, you need to add some information to the page. Click the Site Info panel on the right and start editing the page info. Fill in all of the information that you think is necessary for your gallery (**Figure 8.4**). If there is data you don't want to include, simply click the disclosure triangle next to the item's name and then choose Clear List from the pop-up menu (**Figure 8.5**).

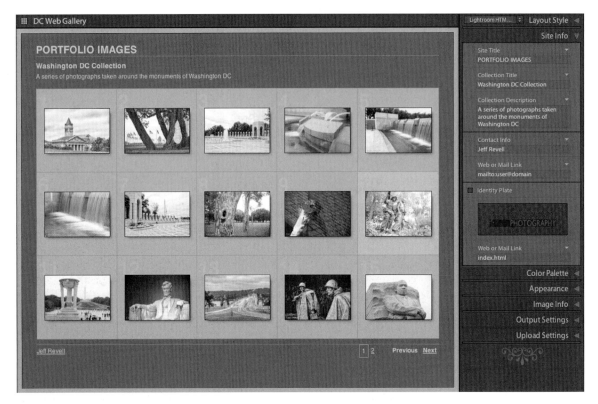

FIGURE 8.4
You can personalize the layout using the Site Info panel.

FIGURE 8.5
To remove an unwanted item, choose Clear List.

FIGURE 8.6
Change the Identity Plate by clicking in the plate window and choosing Edit.

You can also add an Identity Plate just as you did in the Print module but with a couple of exceptions. You can add a text-based Identity Plate by selecting the Identity Plate check box in the Site Info panel, clicking in the text box, and then choosing Edit (**Figure 8.6**). When the Identity Plate Editor dialog opens, type the name you want in the plate and set your font type, size, and color (**Figure 8.7**). It's difficult to know which font size to choose at first, so select 18 or 24 and then click OK to see how it looks on the page. If it is too small or large, go back to the Editor and change it.

You can also use a graphic for your Identity Plate just as you did in the Print module. The key is to make sure that it is sized correctly before adding it to the page. Unlike the Identity Plate in the Print module, you can't resize or move the plate around in your image, so size is important (**Figure 8.8**).

CHANGE THE COLOR AND APPEARANCE

Depending on the template you selected, you may be able to change the colors used in the web gallery. The items available for color customization depend on the template, but changing them is as easy as clicking in the color box and selecting a new color with the eyedropper (**Figure 8.9**). An Appearance panel contains options from let you adjust the layout. The Flash options (**Figure 8.10**) can be very different from those available for an HTML gallery (**Figure 8.11**). You just need to look at the panels and determine which options, if any, need changing. In addition to the color and appearance, you can change the information that you want to appear with each image, like a title, caption, or even camera metadata. You can add these items in the Image Info panel (**Figure 8.12**).

FIGURE 8.7
Adjust the font, color, and size using the Identity Plate Editor.

FIGURE 8.8
You can add a graphic as an Identity Plate for your gallery.

FIGURE 8.9
You can change the color scheme of your page in the Color Palette panel.

FIGURE 8.10
Changing the Appearance panel options for a Flash page.

FIGURE 8.11
The Appearance panel options for an HTML page.

FIGURE 8.12
You can add text information to your layout using the Image Info panel options.

FINALIZING YOUR WEB FILE

When you have everything laid out the way you want, you need to complete two more steps. The first is to save your changes as a new User Template. As in other modules, click the plus (+) symbol on the Template Browser title and then name the template (**Figure 8.13**). After you have saved the template, save your web gallery. This is a new feature in Lightroom 4, so if you are using an earlier version, you can skip this step. If you are using Lightroom 4, go the main Lightroom menus and choose Web > Create Saved Web Gallery. You can also press Command+S (Ctrl+S) or click the Create Saved Web Gallery button above the main layout window in the document bar. When the Create Web Gallery dialog appears, fill in the name and collection location where you want to save your gallery (**Figure 8.14**). Once you save your gallery, Lightroom allows you to continue working on other images. When you've finished, you can jump back to your gallery and make changes or even upload it to a server.

After saving your template and your web gallery, it's time to get it ready for the Internet. In the Output Settings panel choose a quality setting for your images. This is also where you can select whether or not to place a watermark on all your images in the gallery. Next, select the amount of sharpening you want to apply. I typically use the default settings of 70 for quality and Standard for sharpening (**Figure 8.15**).

The last step is to upload your images or save the files for uploading at a later time. If you already have a web server and know the server information, choose Edit in the FTP Server section (**Figure 8.16**). A Server dialog opens to input your information (**Figure 8.17**). If you don't know the server information, contact your server host company and ask for the settings. When you have filled in the information, click the Upload button at the bottom of the panel. Lightroom then creates your gallery files and uploads them to your server.

FIGURE 8.13
Save your layout as a new template for future use.

FIGURE 8.14
In Lightroom 4 you can save your gallery with all the included images.

FIGURE 8.15
The Output Settings determine the quality of your online images.

FIGURE 8.16
Choose Edit to set up your FTP server info.

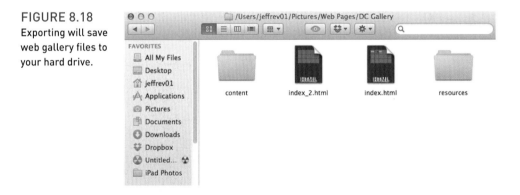

If you don't have a server provider yet or aren't sure if you do, save the web files
to your hard drive by clicking the Export button, located at the bottom of the right
side panel. A Save dialog opens. Choose a name and location for your web files.
Lightroom will render all of the photos, create the web files, and store everything in
a folder ready for uploading (**Figure 8.18**).

FIGURE 8.18
Exporting will save
web gallery files to
your hard drive.

MAKING A SLIDE SHOW

This isn't your grandfather's slide show I'm talking about. Lightroom has the tools to
help you create a dynamic slide show that won't put your audience to sleep after the
first 30 seconds.

Let's start with that same group of images that you used for the web gallery. Click
Slideshow in the Module Picker to begin. Only a few templates are available to work
with in the Slideshow module, and they are pretty basic, so I suggest you start with
the default settings and begin modifying them to your liking.

SETTING UP THE CELL

The Slideshow module works similarly to the Print module in that your image will sit inside a cell, although it's called a *frame* in this module. The Options panel lets you choose whether or not you want your photos to fit or fill the frame. You can also choose to put a stroke border around the frame and have it cast a drop shadow on the background (**Figure 8.19**).

The Layout panel is where you determine the size and shape of your photo frame. If you leave all the sliders linked, the frame will adjust equally on all sides. If you want to use a different-sized frame and not have it centered, you need to unlink the sliders and move them accordingly (**Figure 8.20**).

If you want to change the color scheme, a good place to start is the Backdrop panel. You can not only change the color of the slide show background, but you can also create a color wash, which is like a gradient that changes from one side to the other (**Figure 8.21**).

FIGURE 8.19
The Slideshow Options panel.

FIGURE 8.20
Use the Guide sliders to adjust the size and location of your photos.

FIGURE 8.21
You can change the background color and add a color wash using the Backdrop panel.

If you really want to get fancy, you can use an image as a background. Just drag and drop it into the Background Image box in the Backdrop panel and set the opacity (**Figure 8.22**).

FIGURE 8.22
You can use a photo as your background by dragging it into the Backdrop panel.

ADDING INFORMATION

The Overlays panel lets you add information on top of your slides. To start with, you can add the now familiar Identity Plate in both text and graphic form. Unlike the web gallery, you can move your Identity Plate all over the slide and resize it to your liking. You can also add watermarks, star rankings (which appear in the corner of the photos), and text overlays (**Figure 8.23**).

FIGURE 8.23
Add watermarks, Identity Plates, and even star rankings in the Overlays panel.

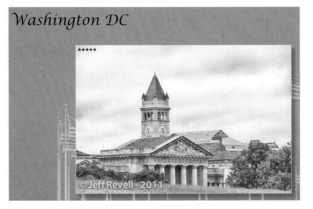

ADDING TITLES

Because you are making a show, you should kick it off with a title, and what's a show without closing credits? Fortunately, you can create title slides for the start and end of your slide show using the Titles panel. Truth be told, this feature is a little squirrelly but it does work if you know the secret. Turn on the Title slide by selecting the check box next to Intro Screen, Ending Screen, or both. This places a default black screen at the beginning and/or end of your show. You can change the color of the screen using the default color picker in each panel section (**Figure 8.24**).

If you want to add text, you can do so by adding an Identity Plate. You'll need to set one up for each screen. But here's the weird part. When you select the Intro or Closing Screen option, the screen will only appear for a couple of seconds and then disappear. This makes it very difficult to see your text and change its size. The trick is to click and hold on the triangle in the Scale slider; the screen will stay visible and you can resize your text. When you let go of the mouse button, the screen will disappear again. Weird, huh?

FIGURE 8.24
You can add simple title and ending screens using the Titles panel.

PLAYBACK OPTIONS

To finish your slide show, you might want to add a music sound track or control the duration of your slides. All of this takes places in the Playback panel. If you want to add a sound track, select the Soundtrack option, click the Select Music button, and locate the music track that you want to use for the slide show. If you want the slide show duration to match the length of the song, select the Slide Duration check box, and then click the Fit to Music button to adjust the duration time for the slides (**Figure 8.25**).

You can also have the slides run in random order by selecting the Random Order check box. In addition, you can reorder your slides by dragging them around inside the Filmstrip. Just drag and drop the photos until they are in the order that you want from left to right.

FIGURE 8.25
Add music and control slide duration in the Playback panel.

If you want to use only specific slides from the Filmstrip, change the selection preference by clicking the Use option in the slide show control bar at the bottom of the layout window (**Figure 8.26**). You can preview your slide show by clicking the Play button on this bar as well as add a slide text overlay by clicking the ABC button.

FIGURE 8.26
Select the method for determining which images in the Filmstrip will be used in the slide show.

To play a full-screen version of your slide show, click the Play button at the bottom of the panels on the right. You can pause the slides by pressing the spacebar, but it doesn't pause the music. If you want to see a preview of your slide show, click the Preview button to the left of the Play button. This will start the slide show but not at full screen. It will play inside the layout window and is useful for checking your transitions and slide timing.

If you aren't available to show the slide show on your computer, you have two options for sharing it. If you want the actual look and sounds of the slide show, click the Export Video button to turn the show into a video that you can then give to others to play on their computer. You can also upload the file to a video sharing site like YouTube or Vimeo. Just click the button, name your file, set the video output size, and click the Export button (**Figure 8.27**).

FIGURE 8.27
Slide shows can be exported as high-quality video files.

For a more static version, click the Export PDF button to render the slide pages as a PDF document that can easily be shared on a CD or even via email. Of course, there won't be any music in the PDF version.

PUBLISHING SERVICES

Starting in Lightroom 3, Adobe added publishing services for uploading photos to online sites like Flickr and Facebook. One of the benefits of using the publishing service as opposed to just exporting and downloading is that the service will keep track of your uploaded photos. So if you make any changes to your images after upload,

Lightroom will keep track so you know if you have the most current version uploaded and also provide you with a way of updating them.

SETTING UP A SERVICE

Flickr is a very popular photo sharing site. It is also one of the sites that lets you use your account to upload your images directly from Lightroom when you are ready to share them. To set up the Flickr service, go to the Publish Services panel in the Library module (it's located in the lower portion of the panels on the left) and click Set Up in the Flickr section to open the Lightroom Publishing Manager (**Figure 8.28**). The Flickr service should be highlighted in the Publish Services section on the left.

FIGURE 8.28
Use the Publishing Manager to set up your Flickr account and upload options.

You'll need a Flickr account to use this service, and Lightroom will need you to log in to upload your images. Clicking the Log In button will open a dialog that will ask you to authorize Lightroom to upload to Flickr (**Figure 8.29**). Clicking the Authorize button will take you to Flickr where you will need to click through one more authorization screen. When you're done, you can return to Lightroom and continue to set up your export options. The options are pretty self-explanatory and will only take a few seconds for you to set up. Click the Save button to close the dialog when you're done.

FIGURE 8.29
You must authorize Lightroom to use your Flickr account.

FIGURE 8.30
Drag photos from the Grid into your Photostream.

FIGURE 8.31
The Photostream displays the number of images that have been added.

ADDING PHOTOS

Once the service is set up, you'll see a new item added below the Flickr section in the Publish Services panel that reads Photostream. This indicates the number of images you have uploaded with the service. To add images, just locate them and then drag them into the Photostream (**Figure 8.30**). When you have added all the photos you want to upload, click the Photostream title to see how many photos you have added (**Figure 8.31**). When you are ready to send them to Flickr, click the Publish button at the bottom of the panels on the left. After the images have been published, open your web browser to your Flickr page and check out your images (**Figure 8.32**).

As you add images, they will appear in the Published Photos section of Grid view. If you modify any of the images that were uploaded, they will be added to a section above the Published Photos section and labeled Modified Photos to Re-Publish. If you click the Publish button again, Lightroom will send only these modified images to the service to replace the previous versions (**Figure 8.33**).

FIGURE 8.32
After publishing, your images will be uploaded and ready to view in Flickr.

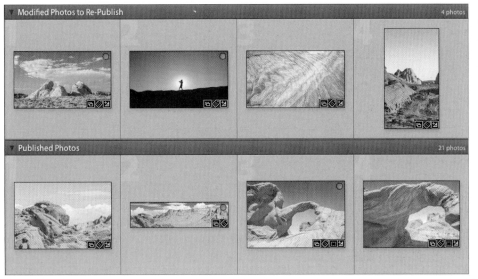

ADDING A SERVICE

Lightroom has included a couple of the most popular photo services for you to use, but you might want to use one that isn't included in the list, which is why Adobe included a button to let you find more services through its online Exchange program. If you find a service you want to use, you will eventually download a plug-in file that will add the service to your list. To add the service, choose File > Plug-in Manager in Lightroom. When the manager opens, click the Add button at the bottom of the list of installed plug-ins. Locate the plug-in file you want to add, and click the Add Plug-in button (**Figure 8.34**). Lightroom might display a warning telling you that the catalog must be updated to use the plug-in. Go ahead and click the Update Catalog button to finish adding the service (**Figure 8.35**). Click Done in the Plug-in Manager dialog and then look in your Publish Services panel to locate your new service (**Figure 8.36**).

TIP

If you want to use the 500 Pixel Publishing Service, go to http://500px.com/lightroom and click the download link to get the plug-in.

FIGURE 8.34
Use the Plug-in Manager to add a downloaded Publish Services plug-in.

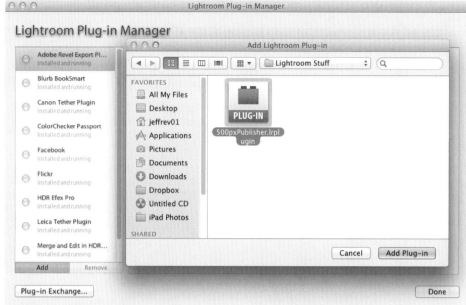

FIGURE 8.35
Some new plug-ins require an update to the catalog.

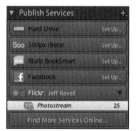

FIGURE 8.36
Newly added services will appear in the Publish Services panel.

EXPORTING YOUR IMAGES

Throughout this book I've mentioned that one of Lightroom's many benefits is that it never really alters your original images. This is great for working within the program, but sometimes you'll need copies of your photos to send in an email, give to your clients, or send to a printer. You don't want to just copy the images from their folder locations, because these files wouldn't contain all of the edits that you've made in the Develop module. That's when you turn to the Export function.

USING A PRESET

To open the Export dialog, choose File > Export. You can also access the Export dialog by pressing Shift+Command+E (Shift+Ctrl+E). When the Export dialog opens, locate the Presets in the panel on the left (**Figure 8.37**). Several Lightroom presets let you export your images to email, as DNG files, as full-size JPEG files on a CD/DVD, or as files on your hard drive for emailing later.

FIGURE 8.37
The Export dialog.

The real key to using the presets is to select one of the existing presets and modify the options to save it as your own. This should sound pretty familiar by now because you've done this with presets in several of the other modules.

CHANGING THE SETTINGS

I use the Export function all the time. In fact, many of the images in this book were created by exporting the images using my own preset. Here's an example of how I would set up a preset for this chapter.

1. In the top of the dialog, change the Export To option to Hard Drive (**Figure 8.38**).

FIGURE 8.38
Choose the destination location for the exported photos.

FIGURE 8.39
Set the export folder location.

FIGURE 8.40
Choose the exported file format.

FIGURE 8.41
Set the output size for the exported images.

FIGURE 8.42
Select what happens after the images are exported.

FIGURE 8.43
Save your new export options as a preset.

2. Set the Export Location to my Lightroom Book folder, and then create a subfolder called Chapter 8 (**Figure 8.39**).

3. Leave the File Naming and Video settings unaltered, and then change the File Settings to save the file as an 8-bit TIFF with Adobe RGB(1998) Color Space (**Figure 8.40**).

4. Set Image Sizing to Resize to Fit the Long Edge to 2000 pixels (**Figure 8.41**).

5. Set the After Export option to open the image in Photoshop (so I can convert the image to CMYK color space) (**Figure 8.42**).

6. Click the Add button and save the settings as a User Preset (**Figure 8.43**).

You need to search through all of the options to determine which ones to change for your particular needs. Once you've saved your preset, you can easily export your images with just a couple of mouse clicks. Just make sure that you select the images that you want to export before you start the process.

EXPORT FOR EMAIL

If you are using Lightroom 3 or earlier, you'll have only one preset for email. This preset will export your images to a folder on your hard drive. You can then go to your email program and attach the files to your outgoing message. Just remember to check your image sizes so that they aren't too large. I like to keep mine at 800 pixels along the long edge of the image.

If you are using Lightroom 4, you have a new email preset that will load the images into a new message when you're done setting the options. To use it, click the For Email preset, and then set your file options accordingly (**Figure 8.44**). When you click the Export button, a new dialog appears with thumbnails of your images already set as attachments. Type an email address for the recipient and a subject, and then click Send (**Figure 8.45**). After Lightroom finishes the export, your mail program will open with a new email message with your images all set for sending (**Figure 8.46**).

FIGURE 8.44
Choose the appropriate email preset.

FIGURE 8.45
Enter an email address and subject in the dialog and click Send.

FIGURE 8.46
Photos will be exported into a new outgoing message using your email program.

CONCLUSION

There is no big secret or silver bullet that will transform your images into works of art. It's mostly just getting the shot right in the camera and then applying some sound, basic image adjustments that transform average-looking photos into vehicles that express your vision. The most important part of image processing is being able to look at a photo and know what it needs to look better. This doesn't happen overnight. It takes time and practice to become skilled at image editing, but the more you work at it, the better you will become. And with the skills and techniques that you learned in the last few chapters, you should be well on your way to producing stunning images.

Chapter 8 Assignments

All right, it's time to put all this practice to some good and start sharing those photographs. You have so many options available for sharing your new works of art that the only problem you might have is deciding what to do first.

Share a Slide Show on YouTube

You know you've been dying to show off some of your favorite photos, so now is the time. Create a slide show of your favorite images, and then export them to a video. Try using the 720x480 video preset so the file won't be too large. Then upload the video to YouTube and share it with your friends. It only takes a minute or two to set up an account if you don't already have one, and it's free.

Get Your Work on the Web

What's that? You don't have your work on the Internet yet? Well, now you have no excuse for not showing off your best shots. Head to the Web panel and create a new web gallery using one of the templates. Customize it with your personal information, and then find a web host. If you don't want to pay for a hosting site, just do a Google search for "free web hosting." You can actually find many free hosting sites that you can use for uploading and sharing your gallery.

Create Some Export Presets

I use presets all the time and have numerous presets set up to quickly get my work out of Lightroom and into another application. I have a preset for my blog photos, one for email, another for book images, and even one for sending prints to an online printing service. Creating them is easy, so give it a try. They will save you time and effort in the future.

Share your results with the book's Flickr group!

Join the group here: flickr.com/groups/photoshoplightroomfromsnapshotstogreatshots

INDEX